NORTH WESTERN JOURNEYS

North Western Journeys

Spokane Pioneers and Scablands Settlers

JOHN W. LAWTON

Dedicated to the memory of my Father, Walter W. Lawton.

And

Dedicated to my first cousin, Gwen (Dyer) Hodkinson, who I visit as often as I can, and who helped with this work. They were the only two children born while the family was at Fishtrap.

America Through Time is an imprint of Fonthill Media LLC

First published 2017

Copyright © John W. Lawton 2017

ISBN 978-1-63499-015-8

All rights reserved. No part of this publication may be reproduced, stored in a retrieval system or transmitted in any form or by any means, electronic, mechanical, photocopying, recording or otherwise, without prior permission in writing from Fonthill Media LLC

Typeset in Minion Pro 10pt on 13pt

Published by Arcadia Publishing by arrangement with Fonthill Media LLC
For all general information, please contact Arcadia Publishing:
Telephone: 843-853-2070
Fax: 843-853-0044
E-mail: sales@arcadiapublishing.com
For customer service and orders:
Toll-Free 1-888-313-2665

Visit us on the internet at www.arcadiapublishing.com

Printed and bound by CPI Group (UK) Ltd, Croydon, CR0 4YY

Foreword

A Hundred Years Ago

Where, where are all the birds that sang
A hundred years ago?
The flowers that in all beauty sprang
A hundred years ago?
The lips that smiled,
The eyes that wild
In flashes shone
Soft eyes upon;
Where, O where are lips and eyes
The maiden's smiles, the lover's sighs,
That lived so long ago?

Who peopled the city streets
A hundred years ago?
Who filled the church, with faces meek,
A hundred years ago?
The sneering tale,
So mean and frail,
The plot that worked
A brother's hurt,—
Where, O where, are plots and sneers,
The poor man's hopes, the rich man's fears,
That lived so long ago?

—Anonymous

Acknowledgements

There are two people whose help was essential to the completion of this work. My wife, Carol, helped all along the way with reading, transcribing and interpreting source documents such as letters and diaries. She reviewed and proofread many drafts. And she accompanied me on several research trips and helped me understand what I was seeing.

Patricia Alexander is the writing coach and guru of the North County Writing Support Group in Paso Robles, California. I am a participant in this group when I am in California. I have been helped immeasurably by working through my writing with Patricia and others and by receiving their invaluable comments, suggestions, and other assistance.

Many others have helped whose contributions are part of the story and as such are acknowledged in the text and in the Bibliographic Essay.

Contents

Foreword 5
Acknowledgements 6
Prologue 9
 The View from the Mountain Top 9
 What You Need to Know About Us 11

PART ONE: PAINTING SPOKANE
- 1 Spokane by Wagon Train and Rail 17
- 2 The Bump Brothers and the Butter Fire 21
- 3 Building Lives—Then Tragedy 26

PART TWO: EARTH, ROCKS, AND SETTLERS: THE FLOWERING AND WITHERING OF FISHTRAP AND LAKE VALLEY
- 4 A Harsh and Beautiful Land 41
- 5 They Planted and Harvested in the Harsh Scablands 46
- 6 Stresses at Fishtrap—1912 60
- 7 Strains in Portland—1912 70
- 8 The End of the Dream 78
- 9 The Exodus 89

PART THREE: AN OVINE JOURNEY
- 10 The Call of the Mountains 99
- 11 Alone in the Mountains 110
- 12 Night Terrors 115
- 13 The Return 119

Bibliographic Essay 125

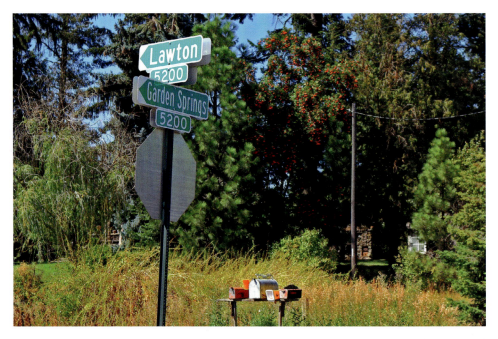

"Lawton" road in the Garden Springs area on the west side of Spokane near the site of the Lawtons' second home in the area.

Lawton Road through one time Lawton property. The Fishtrap community was just over the rise in the distance where the road cuts through the hill.

Prologue

THE VIEW FROM THE MOUNTAIN TOP

My paternal grandfather and I missed each other by some 28 years. As I become closer to my own grandchildren I realize what a loss it was for both of us. John Willis (Will) Lawton was born in 1863 and died in 1915. Had he been around to greet me, his namesake, on the occasion of my birth, he would have been 80 years of age. My grandmother, Irene L. Lawton (nee Lizzie Irene Bump), passed on when I was about six years old. In spite of my young age at that time, I still feel like I knew her, and the strength of her life was felt long after she died. On the other hand, I was too young to remember any stories she may have told about my grandfather or other family. No one talked much about the family history. Some were interested in genealogy, but I didn't hear many stories about my grandparents or great grandparents. I think there was a pervasive overlay of grief about my grandfather's death and the subsequent loss of family livelihood and status that sealed up the tales of earlier times. Some of this is undoubtedly due also to our natural inclination to forget to talk about or be interested in such things until it is too late to tell stories or ask questions.

What I knew about my grandparents and their ancestors could have fit on a standard 300 word page, with room to spare, until my father passed on in 1995 and I found the letters. My dad kept every card and letter he had received from his wife and children through the years. He kept them in a large box where they languished, in a dusty storage shed, until he died. In a bottom corner of the box I found a bundle of some 20 or 30 letters from my grandfather to my grandmother, all written in 1912 when my grandfather had spent three months in Portland, Oregon, as the painting and decorating contractor for a new hotel, while my grandmother remained at the family homestead west of Spokane, Washington. Through my grandfather's writing I saw him and heard his voice for the first time.

The letters opened my eyes to the possibility of learning my history and launched me on a quest to discover as much as I could. They contained the glimmerings of family stories from my grandparents' generation and before. As well as containing stories of their own, they pointed to other stories to be teased out of letters, diaries, newspapers, local histories, photographs, oral histories, and academic works. I set out on a several year search that went literally from coast to coast to uncover a family history of which I was largely unaware. I still wish I had first person narratives to pass on as they were told to me. On the other hand, it is amazing how much one can learn in other ways with diligent research and a bit of luck.

These stories begin with a quick sketch of the Lawton family whose first ancestor arrived in Massachusetts in 1635, and whose succeeding generations followed the cutting of forests across the northern tier of states, until they arrived in the Spokane area in 1890. John Willis (Will) and Irene Lawton had followed a string of Wisconsin settlers from the Eau Claire area, where the pine forests were playing out after a logging frenzy lasting 25 years or so. They successfully established homes and businesses in Spokane, and then in 1906 they left the city and settled about 25 miles to the west in Lake Valley, where they bought land, took up a homestead, and commenced farming and establishing businesses. This dream worked for a while, but family misfortune and flawed economic assumptions eventually led to the loss of everything they had built. Until that time the family had been multi-generational and closely knit. By 1920 the family had scattered because of untimely deaths and the economic collapse of the homesteading dream. As a boy on his own, Walter Lawton, Will's son and my father, spent three years in Idaho's mountains herding sheep to get by, something unthinkable today.

The stories are told in a three part narrative. The first consists of the Spokane years where Will and Irene made their lives after their arrival from Wisconsin. This period illuminates some of the themes of the history of the American West from the point of view of ordinary people; themes such as the wagon trains, the great railroad migration, and the nearly overnight building of cities where none had been. It helps us remember how some of these motifs relate to the settlement of Spokane. It also reminds us how little of the actual settlement of the American West has to do with the stuff of western paintings, endless bronzes, movies, and songs, including cattle drives, cowboys, gunfights, Indian attacks, and the like. Rapid urbanization stemming from the influx of tens of thousands of rail-borne immigrants is not nearly so romantic.

Part Two is about homesteading in the most unlikely of places, Lake Valley, and the flowering and almost immediate withering of a small homesteading community and rail stop there called Fishtrap. After some 15 years in Spokane, Will and Irene homesteaded at Fishtrap in 1906 and built a store, post office and inn, all incorporated into the same building. This story illustrates the cycle of settlement in arid and semi-arid western lands, beginning with open range cattle and sheep grazing, then homesteading with subsistence, then market based farming, followed by drought and decline, and finally returning to grazing but within the confines of fences.

Part Three is the early story of my father, Walter Lawton, son of Will and Irene. He was cast adrift in his early teens by the death of his father when he was just seven, and the subsequent inability of the family to hang on to farm and business. In the early 1920s, Walt set off herding sheep across the channeled scablands of Eastern Washington, and on into Idaho's Bitterroot Mountains where he spent his fifteenth birthday with 2,000 sheep, a camp tender, and a couple of dogs. Moving sheep from protected plateaus and valleys where they winter, to summer pastures in the mountains, is a time worn practice which survives in some parts of the world and on a small scale in this country yet today. At the time, it was an economic mainstay of the region.

A bibliographic essay detailing the many sources for this work is provided. Photographs are included in each section. Names of major characters are set out in bold type the first time they appear.

WHAT YOU NEED TO KNOW ABOUT US

As a child I was told a few things about the Lawton family, some of them true and some not.

1. I was told that the Lawtons descended from four Scottish brothers who immigrated to America and had a subsequent falling out, with two of them changing the spelling from "Laughton" to "Lawton." This was pure fiction, except that the name was changed, for reasons unknown, as we shall see below.
2. It was said that women in the family were eligible for membership in the Daughters of the American Revolution. This is probably true. Among the direct line of Lawton ancestors, there was a documented member of Vermont's Green Mountain Boys of Revolutionary War fame.
3. Among our long list of great-something grandmothers, we have both a Pennsylvania Dutch and a Native American grandmother. The former is true, and easily documented. The latter is plausible, but hard to confirm. Along the northern tier of states there was intermarriage among the settlers and the native tribes such as Chippewa and Cree. Among the grandmothers there are French names, which could trace back to intermarriages with French trappers. Incidentally, in a Civil War record and in photographs, some of the Lawtons seemed to be dark complexioned people. This is not really evidence, let alone proof. Sometimes people who may not actually have it, claim native ancestry, but I will make no claim unless we find evidence, such as DNA test results, that goes beyond family legend.

The point of all this is that I was told a very few family stories and these were not all that credible. So my grandfather's letters stimulated me to put his story in the context of a reliably accurate portrayal of the family's story, and to the extent possible, to record highlights of their lives with their successes and tragedies.

On May 27, 1879, Will Lawton's father, Lewis, died in Eau Clair, Wisconsin of a massive stroke. Will was sixteen, his sisters Flora, May, and Sarah were seventeen, fourteen and seven, respectively; and his younger brothers Oscar and Frank were nine and five. Lewis was just 50 when he died and his wife Maria was 38. Mother and children were devastated, of course, and faced an uncertain future without their primary breadwinner. Just 36 years later history would repeat itself with uncanny similarity and equally devastating results.

The Lawton family was of Yankee New England stock with the first Laughton (changed by Lewis' father, Fordyce, to the present spelling) ancestor arriving on the ship *Elizabeth*, at Lynne, Massachusetts, in 1635. Generation by generation, the family followed frontier and forest north and west from Massachusetts to Vermont, upstate New York, briefly to Western Pennsylvania, and then to Wisconsin. Lewis, Maria, Flora, and Will, along with Lewis's mother Abigail, and Maria's mother Louisa Clark, moved from Pennsylvania to the Eau Claire, Wisconsin, area around 1864, soon after Will was born.

Eau Claire and the surrounding area were entering a boom era which lasted through most of the rest of the century. This period of plenty owed itself to the massive cutting of pine forests in the area and rafting both raw logs and cut lumber down the Chippewa River to the Mississippi and thence to Illinois, Missouri and points south. Among the early waves of workers to pour into the area, were Yankees who had previously followed the logging and

milling industries in New York and Pennsylvania. Lewis' father, Fordyce, had built and sold a sawmill in Pennsylvania, and his brothers Milan and Jay were carpenters and wood workers by trade. Lewis and his brothers drifted to Wisconsin from Pennsylvania during the Civil War along with other family members, including their sisters.

One of Lewis' brothers, Myron W. Lawton, enlisted in the Union Army from Eau Claire on the last day of 1863. Five months later he died of dysentery in St. Louis and was brought back to Eau Claire for burial. Two other brothers, Charles M. Lawton and Sewell DeLafayette Lawton were Union Army men who enlisted from New York and Pennsylvania and who also died of disease in the latter days of the war. The three brothers joined a host of Union Army casualties, two thirds of whom died of disease rather than combat wounds.

The family seemed ordinary enough, making their living along with thousands of others without leaving much of an imprint on the area. Lewis' brother Milan J. Lawton, also known as M.J., made the local newspaper at least once, however. Late one night a couple of days before Christmas in 1886, he heard the clothesline creaking. Rushing to a window he spotted a man filching clothes from the line. As M.J. moved to the door, the man saw him and sprinted for the back fence taking only a pair of socks. When the pathetic thief reached the fence he saw that the socks had holes in the heels and tossed them before vaulting the fence and vanishing. The reporter, apparently a newsroom wag, couldn't resist pointing out that "he evidently was not partial to holy stockings." This amusing but inconsequential incident may also provide an indication of the family's frugality and relative obscurity.

After Lewis' death, Will went to work as a laborer and then developed a trade and business for himself as a painter and paperhanger. He and his mother and sisters and brothers lived in Eau Claire, and for several years he and a partner did business there as Lawton and Kane, "General Contractors in House, Sign, and Carriage Painting, also Graining, Hardwood Finishing, Paper Hanging, Kalsomining, and Glazing done in the latest styles of the day." His mother took in washing assisted by Will, who did pickup and delivery, and by the rest of the children. They undoubtedly were active in church since the family had already been Methodist for at least a couple of generations. Will also attended temperance meetings which were part of the social and political landscape of the day. So life went on; the family stayed together with Will as the man of the family, and eked out a living through enterprise and hard labor.

On April 23, 1881 the family endured another tragic loss when seven year old Frank Myron died. We have no record of what happened although diphtheria carried away many of the children in that time and would have a devastating impact on the family in the next generation. Still another tragedy occurred when Will's sister Flora died in 1888 leaving a two year old and a widowed husband. She most likely died of a stroke which was the result of the hypertension that eventually wiped out that entire Lawton generation, some at very early ages. She was just 26.

Will met Lizzie Irene Bump in 1887 when he picked up and delivered washing from the Bump family in the nearby village of Mondovi. The Bump family traced their lineage to French Huguenots, originally named Bompasse, who had migrated to England in an earlier century to escape religious persecution. The Lawtons also bought butter and other products from Irene's parents' farm. Will and Irene were married in Mondovi on a rainy day early in May in 1888, two months after Flora died. He was 25 and she was 22. On the day they were married, Irene's father, Jay W. Bump, gave her seven dollars. The young couple made their first home

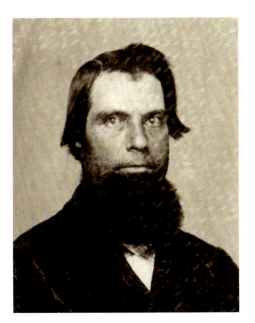 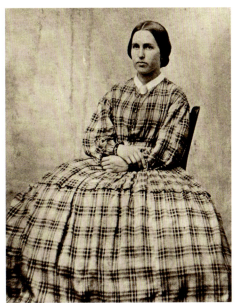

Above left: Lewis Lawton, Will Lawton's father, who died of a stroke in 1879 leaving a wife and five children.

Above right: Maria (Clark) Lawton *c.* 1861, the year she married Lewis.

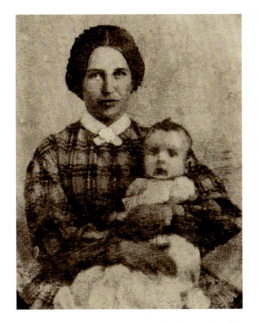 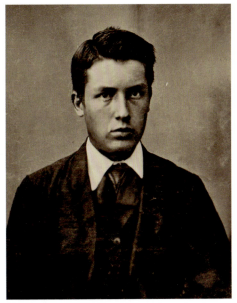

Above left: Maria Lawton and first-born daughter Flora about 1864. This is the only known photo of Flora who died in 1888 leaving behind a young husband and a two-year-old.

Above right: John Willis (Will) Lawton, *c.* 1880 at about age 16.

in nearby Chippewa Falls. Their first son, Merrill, was born on March 16, 1889, about a year before they packed up their families and once again followed the frontier west.

By 1890 the forest products boom was winding down in the Eau Claire area. Most of the forests had been cut and shipped down the rivers to build Midwestern cities. Far to the west a new frontier boom town was beckoning, this time pine-forested Spokane, in the Washington Territory. In the late winter of 1890, Will and Irene along with several family members boarded the Chicago, St. Paul, and Minneapolis Railway for St. Paul where they would transfer to the Northern Pacific Railway for their journey to the Pacific Northwest.

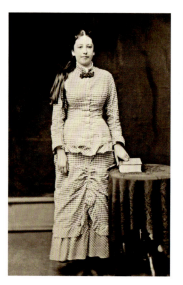
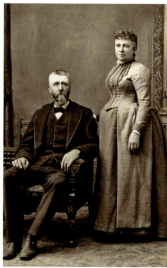

Far left: Irene L. Lawton (née Lizzie Irene Bump) at about age 16 or 17. She married Will Lawton in 1888.

Near left: Jay W. and Charlotte (Thomas) Bump, Irene's parents, who were part of a large group of family, friends and neighbors who migrated from Mondovi, Wisconsin, to Spokane in the 1880s and 1890s.

The home the Bump family left when they migrated from Mondovi, Wisconsin, to Spokane in 1890. This copy was made by a Spokane studio.

PART ONE
PAINTING SPOKANE

1

Spokane by Wagon Train and Rail

When I was a child, my great-grandfather's diaries, some 40 years' worth, slumbered year after year in a shoe box, resting on a shelf in my parent's bedroom closet. Jay W. Bump, Irene's father, my dad's grandfather and my great-grandfather, kept a diary for most of his adult life. Why I was always aware of the diaries and never the letters is a mystery I may never resolve. My best guess is that the letters were kept by one of my father's sisters who had passed on, and he simply inherited them, put them in a box and forgot about them. Or, it may have been too painful for him to read or even see them given what happened.

No one ever read the diaries because they were cryptic and difficult to decipher because of the handwriting. Moreover, most of the entries had to do with the daily weather and an accounting for expenditures and business transactions, dry stuff indeed. But when I found the letters and my appetite for the family history was whetted, I delved into the diaries and mined them for dates and places of events, stories buried amongst the minutia, and a double check for things I had discovered from other sources. There were instances where my grandfather's letters and my great grandfather's diaries made a beautiful fit for telling a story such as the fates of Will and Irene's first three children. The diaries provided the foundation for constructing the narrative of the extended Lawton family's years in Spokane.

When Will and Irene and their baby boy arrived in Spokane on the Northern Pacific Railroad in early 1890 they brought Will's extended Lawton family and soon were joined by Irene's parents, Jay and Charlotte (Lottie) Bump, and the rest of their family. The members of these two family groups, comprising some 15 people, all came to Spokane within about two months of each other. But they were not coming to dwell among strangers because friends and neighbors had been coming to the Spokane area since 1878, first by wagon train, then by rail, from the Mondovi, Wisconsin, area.

On May 1, 1878 a wagon train left Mondovi with 42 people bound for the Washington Territory. That part of Wisconsin had been settled by homesteaders a generation earlier, and now some of the same people who had founded Mondovi were off for still another promise of a better opportunity. Some of the names in this group of pioneers were C. D. and Lucy S. Ide, George L. Ide, Ernest W. Ide, and Mr. and Mrs. E. B. Gifford. One Clint Gardner was elected captain of the wagon train.

The little band of people and their horse-drawn wagons headed southwest through a corner of Minnesota, across Iowa, down to Omaha, and then more or less due west to Ogden, Utah.

Sample pages of Jay Bump's diaries. A man of few words, he kept 40 years of brief entries like these. The pages refer to the fire at his brother Gile's "Bump Block" in Spokane.

At Ogden they turned northwest, proceeded to Boise, Idaho, on through the northeast corner of Oregon, and finally into southeast Washington.

About the worst thing that happened along the way was that Gifford accidentally shot a steer when aiming at a jack rabbit and was arrested by a local sheriff, luckily the brother of an acquaintance; and he got off with a $12.50 fine, the equivalent of about $300.00 today. Lucky indeed, given some of the penalties of the day for tampering with someone else's livestock. Details such as where the fine went and who got the benefit of the meat from the steer are unfortunately lost to history.

These pioneers experienced other hardships and adventures including ferocious rain, lightning and thunderstorms, but lost no one and were never in serious danger of Indian attack. Their number increased by one with the birth of a baby along the way. The birth must have been as uncomplicated as it could have been along the trail, since we are not aware of any particular issues. There were established towns with doctors along much of the route. The most hostile threats were from price gouging members of their own race at river toll bridge crossings. A common practice of bridge owners was to foul a river crossing with railroad ties and other debris to prevent travelers from fording a stream, thereby forcing them to use the toll crossing at the going rate.

The Ide family wanted to stay in the Boise area, but was persuaded by the others to keep going. Undoubtedly tired of the journey, the family may have seen Boise as offering land and opportunities similar to Spokane's without another four or five hundred miles of bone jarring, back breaking travel.

After about four and a half months they arrived in Dayton, Washington, on September 14. They had completed a journey of roughly 2,000 miles in some 127 days. This amounted to just over 15 miles per day, give or take, since we cannot be sure of the exact mileage.

A few of them settled in the wheat growing country a few miles west of Spokane where they once again named their place Mondovi. Apparently both places were named by E. B. Gifford, who, according to one account, had read about the fall of the original Mondovi, in present day Italy, after a courageous fight in one of the Napoleonic wars. Originality of place names seemed to be a challenge as people migrated west, since many places ended up bearing the recycled names of the places they left.

The year 1878 was late in the wagon train era, when trails west were well worn. Similar journeys had taken place to the Washington Territory (formerly part of the Oregon Territory) since the 1830s. This wagon train of pioneers preceded the completion of the Northern Pacific transcontinental railroad by just five years. Nevertheless, they arrived just as the growth of Spokane was beginning to take hold. Many members of the wagon train would eventually settle in the city and would become prominent community builders. They would help set off an exodus of Mondovi, Wisconsin, citizens during the railroad migration that would transplant many families to the new western town. The outflow of people was boosted by the depletion of the forests in the Eau Claire region and the attendant economic decline of wood products businesses from the late 1880s on. The Washington Territory with its abundant forests was a natural attraction for people leaving Wisconsin for better opportunities.

Known then as Spokane Falls, the city's population in 1880 was somewhere around 500. The first non-natives into the area were the fur trappers, followed by the traders in pelts and the

inevitable missionaries, then the miners around Colville and the Coeur d'Alene Mountains, the cattlemen and sheepherders, and finally the settlers and city builders. As early as 1810, the fur companies had a settlement and a fort, later disbanded, about ten miles down the Spokane River from Spokane Falls. The settlement that grew into the present day city began near the falls of the river in the early 1870s. The town was first incorporated on November 29, 1881.

The completion of the Northern Pacific rail line when the final spike was driven at Gold Creek, Montana, in 1883, opened the area to rapid settlement from the east. The railroad and land speculators aggressively advertised the wonders of the area in newspapers back east and in Europe, to attract the thousands of settlers they needed to sustain the new rail line so laboriously built. Cheap land and a new start lured tens of thousands of immigrants to Spokane in the last two decades of the nineteenth century.

Although population estimates vary because of the number of transient fortune seekers moving through western towns, Spokane's population grew to nearly 20,000 in 1890. The most explosive period of growth came from 1900 to 1910 with an expansion from about 37,000 to around 105,000.

Spokane's early history can be divided into "before-the-fire" and "after-the-fire" periods. The great Spokane fire of August 4, 1889, wiped out nearly all of the central business area. Some said it started in the kitchen of the Buzzard Café and others claimed it was a careless smoker in a lodging house. In any case, a post-fire tent city immediately sprang up in the ashes, business went on, and a rebuilding boom began. It was about this time that the city dropped the "Falls" from its name and became just "Spokane," something its citizens still argue about from time to time today.

2

The Bump Brothers and the Butter Fire

A before-the-fire railroad immigrant, carriage maker Gile (pronounced with a hard "G") O. Bump, hailing from Mondovi, Wisconsin, arrived in Spokane with his family in 1885. He was Irene's uncle, Jay Bump's brother, and the first of the Bump brothers to arrive in Spokane. He built his business downtown but lost it in the great fire. Gile was followed to Spokane in 1888 by his brother, Mensus R. Bump, and his family. Jay W. Bump, Irene's father, came to Spokane in 1890 as did another brother, Lorenzo, who settled in nearby Post Falls, Idaho. Of six brothers, four migrated to the Spokane area between 1885 and 1890.

The Bump brothers had come to Wisconsin from New York as young adults before the Civil War. They came with their parents and now were repeating what their parents had done before, by migrating west some 30 years later with their children. In Wisconsin, Gile was a carriage maker, Mensus was a manufacturer of fan mills (for grinding animal feed), and Jay was a homesteader, farmer, and sometime woodcutter. Some of the Bump brothers and many of their Mondovi neighbors were veterans of the 25th Wisconsin Infantry Regiment, which fought in the Civil War at Vicksburg and marched with General Sherman to the sea.

In Spokane, Mensus went into the wholesale fruit and produce business with fellow Mondoviites and wagon train veterans Ernest W. and George L. Ide. They called themselves "Bump and Ide," Wholesale Fruits and Commission Merchants. Mensus was also in the real estate business. When Jay came, in addition to his wife Lottie, he brought his son Merton, daughter Alice, son-in-law and daughter, Fred and Lillian Kellom, and son-in-law and daughter, Will and Irene Lawton, and their baby boy, Merrill. When Jay got off the train, he was met by Dan Ide, still another Mondovi emigrant.

Will, in turn, brought his mother, his sisters Sarah and May, and his brother Oscar. Will and Irene were close to her parents; they built their houses next to each other on West Boone Street, on lots purchased from C. D. Ide in Ide's Third Addition. They helped each other build, sometimes went to church and spent holidays together, and assisted in family businesses. And they shared in family mishaps, sorrows and tragedies, which happened regularly and all too soon.

After the Great Fire, Spokane rebuilt and doubled the size of its downtown. Many of the new buildings were built of brick or stone, which of course were more fire resistant. Gile and his partner and fellow church member, Major E. A. Routhe, built the Bump Block at Second and Post. It was a four-story brick building housing their carriage repository on the first floor, although some accounts have the carriage business next door to the west in a smaller building owned by Gile.

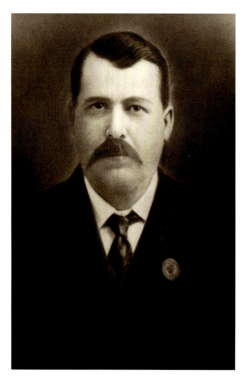

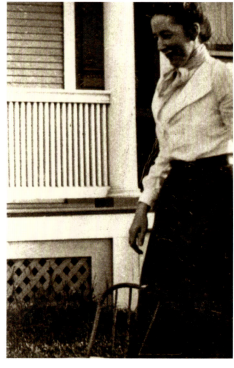

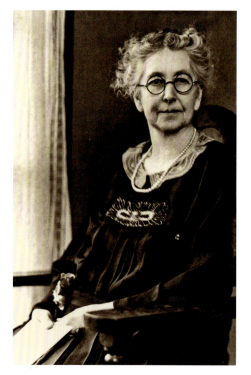

Clockwise from top left:

Will Lawton *c.* 1904.

Irene Lawton about 1904.

Irene Lawton probably after 1915.

The upper three floors were leased to T. W. Harvey, who operated the Belleview House Hotel, and the basement was leased to the Spokane Commission Company, another fruit and produce wholesaler. Still more members of the Ide family were the principals of this business. They were Daniel B., Erwin D. and Henry G. Ide. The recently arrived Jay Bump went to work selling carriages, wagons and farm equipment in the carriage shop wherever it was actually located. At the same time, Will set up his business in another part of downtown as a painter, decorator and paperhanger. He was in a good position to participate in the post-fire construction boom.

On Thursday, August 7, 1890, a few days after Gile left on a trip to Tacoma, the place caught fire and the building was seriously damaged. As Jay noted in his diary, "Giles brick burns at 1:00 big excitement 5 or 6,000 damage to building." This was a lot of damage, since the recent construction cost was about $10,000. Moreover, according to one account most of the city's butter supply was stored downstairs and was destroyed, causing a severe butter shortage until new supplies were brought in. *Un flambeau de beurre!* One can only imagine the scintillating sight, sizzling sound and savory scent of a half-ton or so of flaming, crackling, smoke billowing butter.

Whether the carriage shop was in the first floor of the hotel or next door in an adjacent building, the following things are clear from Jay's diary for 1890. Before and after the fire, Jay went to work every day at the carriage shop selling carriages and wagons. On August 7, 1890 an express wagon was sold for $200.00. The place caught fire about 1:00pm that day. Jay estimated the damage at $5,000 to $6,000, a seemingly large amount for a smaller building. The shop remained open; Jay went to work every day. On August 13, 1890, insurance paid $140.00 in damages to wagons. A "Rockaway" accounted for $60.00 of that. Moreover, to prove that this was not the "ill wind that blew no one good," Will got the job from the insurance company for painting and kalsomining the carriage shop at the then-significant sum of $600.00, perhaps about $15,000.00 today. On September 2, the outside of the brick was painted. On September 4, a new pier was put under the brick. And so on.

Whether "Giles brick" refers to the hotel building or to an adjacent smaller brick building, we cannot know with certainty. But the scale and cost of the work might point to the hotel as the site of the carriage repository. One account concludes that the carriage repository was located next door to the hotel, because there were no doors big enough for carriages on the first floor. Another account concluded that it was in the main building.

Soon thereafter, Gile Bump and Routhe leased the carriage repository to L. L. Land, and Jay was given his discharge. The property fell into the hands of a Dutch mortgage bank after the financial panic of 1893, and it was remodeled. Apparently, Gile Bump lost his financial position in the property with the panic. In 1908 it was sold, four stories were added and it became the Carlyle Hotel, which still stands today, one of the few remaining 1890s buildings in Spokane. It now houses the Carlyle Care Center, an assisted living facility for people with conditions needing assistance. The Carlyle Hotel is on the Spokane Register of Historic Places.

There were many other Mondovi families in early Spokane, and they knew each other, socialized, did business together, sold and rented property to one another and intermarried. Many were members of the Methodist Episcopal Churches in the area, and they were often active lodge members, including Masons, Odd Fellows and Foresters. Besides the Ides, Bumps, Lawtons and Kelloms, there were Giffords, Mayhews, Hunters, Hoyts, Pierces, Carpenters,

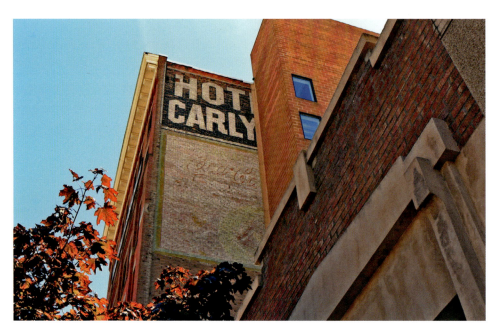

Recent photo of the Carlyle Hotel, which was originally part of the "Bump Block" built by Gile O. Bump, Irene's uncle and Jay Bump's brother, in 1889 after the great Spokane fire.

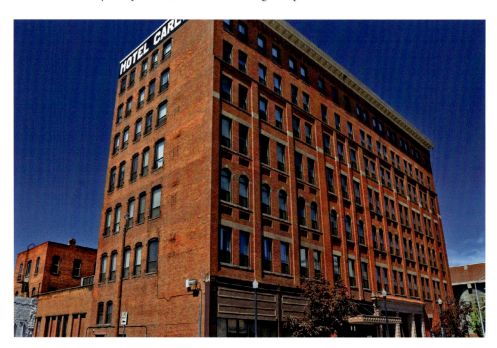

Another recent picture of the Carlyle Hotel. It was originally the "Belleview House Hotel" and had four fewer stories in its original structure. The building is on Spokane's historic register and is one of the earliest brick structures to follow the great fire, although it suffered its own fire in 1890.

Chappels, Christians, Bonds, Frizzells, Thomases, Hanscomes and others. Often there were several related families of the same name. For example, in 1890 there were twelve Ides listed in the City Directory.

Occasionally they were in the news. Mondovi-ite Leslie O. Frizzell was the nephew of Jay and Lottie (Thomas) Bump and was Irene's cousin. Leslie's parents were Orange S. and Emma (Thomas) Frizzell. Leslie was killed in August of 1896 in a fiery train crash near Horse Plains, Montana. A railroad fireman based in Hope, Idaho, Leslie's engine hit a soft spot in a fill that had just replaced a trestle bridge. The tracks spread and two were killed and two injured in the ensuing inferno and boiler explosion. Leslie's sister lived in Spokane, and his mother had just moved there to be near her son and daughter. Leslie is buried in Greenwood Cemetery in the Lawton family plot next to his aunt and uncle, Lottie and Jay Bump. Sadly, he was not the first of the Mondovi emigrants to die prematurely and enter that place.

3

Building Lives—Then Tragedy

Will established his painting and paperhanging business in the wake of the great fire and seemed to have plenty of work, including painting some of Spokane's prominent hotels. That did not keep him from trying other ventures, however, some of which were speculative indeed. For example, he and Jay went prospecting in the nearby Coeur d'Alene Mountains where they filed mining claims which apparently didn't pan out, since the only mention of it is in Jay's diaries. Moreover, there is no evidence of any transfer of resulting wealth to future generations. And in July of 1891 Will and Jay bought half a box of lemons, sugar and ice, rented a spot at the race track and set up a lemonade stand. They each put in $4.45 and the next day they sold $2.15 worth of product. After this enterprise soured Jay spat out the words, "It don't pay & we quit."

In August of 1892 Will and Irene's second child, daughter Rosa May, was born. In the fall of 1892 Will and Jay found land that suited them and they moved to the Garden Springs area just outside the city on the west side. They rented out their places on West Boone and went into the truck farming business. Jay farmed full time and produced butter, eggs, chickens, potatoes, strawberries, corn, beans, cabbage, carrots, cherries and apples for the Spokane market, undoubtedly sold through his brother's wholesale business. Will went into it less intensively since he had his painting business downtown.

Will was an outgoing young man who liked to be around people, especially family. He always seemed to be surrounded by children, grandmas, grandpas, aunts, uncles, nephews, nieces, brothers, sisters and in-laws. Food, both the preparing and the eating, were an important part of his life. He was famous for his Thanksgiving and Christmas dressing; it was said that no one could make better. He read poetry including the classical poets of the day, and of course, his Bible. He was sentimental and expressive, especially about children. Irene and Will were active in the Jefferson Street Methodist Episcopal Church and Will was a member of the Modern Woodmen of America, a fraternal lodge and benefit organization.

Irene was a bit more reserved although hospitable and welcoming to family, friends and strangers, alike. She has been described as being mild in temperament with an underlying "will of iron," likely to prevail in matters she deemed important. She shared Will's love of cooking and baking and was a perfectionist in needlework and quilting. As a young woman she also read poetry, some novels of the time and the Bible. In keeping with the times and with their religious faith, both Will and Irene were Victorian in manners and morals, at least as that term

applied to Methodist settlers in the American West. To us they would undoubtedly seem on the prim and proper side but you really can't judge one generation by the standards (or lack thereof) of another.

Will and Irene spent the first years in Spokane building homes and businesses and exploring the area looking for land. Things were going well for the young family when, four days before Christmas in 1892, disaster struck and any parent's nightmare became their reality. On December 21, three year old Merrill came down with diphtheria. His mother and grandmother stayed up all night with him, and despite a visit from Dr. Penfield, he died the next night. He was buried on Christmas Eve. His father and grandfather had gone over to nearby Greenwood Cemetery the night before the burial and found a family plot for fifty dollars. Then Rosa May, just four months of age, fell sick the day after Christmas. She died two days later and was buried next to Merrill on the 29th.

In just a few days, their lives had gone from promise to devastation as diphtheria took the lives of their little ones. The same disease carried away many children of the time and the pioneer sections of our cemeteries are dotted with their names and dates. The two children

Above left: Will and Irene's first-born, Merrill, at about 18 months. He died of diphtheria and was buried in Greenwood Cemetery on Christmas Eve, 1892.

Above right: The Lawtons' second child, Rosa May, age four months. She fell ill the day after Christmas and was buried next to Merrill three days later. The Lawtons lost a third baby who died a few days following birth in 1894 and was buried next to Merrill and Rosa May.

are buried beside Will and Irene's third baby, who was born in 1894 and only lived for a few days. For the third time, their grandfather Jay had to make the sad trek downtown for shroud, coffin and funeral arrangements.

The three little graves are marked by simple stones and are among the earliest at Greenwood. On the west side of the city, the cemetery is a quiet and peaceful place, cool, green and deeply shaded by towering pines and other old trees. Many of the family who came from Wisconsin are buried in the same plot or nearby. Not far away are many other early Spokane residents such as Garry, Chief of the Spokane Indians, and Jimmy Durkin, a legendary saloonkeeper.

Twenty years later, the memory was still heavy on Will's heart as he wrote to Irene from Portland, where he had gone to paint and decorate a new hotel on the edge of downtown:

> [T]oday is Decoration Day and you ought to see the flowers
> I never saw so many roses in all my life put together
> As one can see every day between here and downtown.
> We go right past the cemetery. It is about ½ mile long
> And one solid field of roses with the monuments in between.
> Roses of all kinds and colors besides lots of other flowers
> And all kinds of ornamental trees.
> It just made my heart ache to see the hundreds of graves
> Just loaded down and covered with beautiful flowers
> And to think there was not one poor little flower
> On our little ones' graves today.
> I do hope that it won't be long until we can be
> Where we can visit their graves once in a while.

The parents started their family over again in 1896 when their daughter Erma was born. By this time they were both in their thirties. Will and Irene lived in the Garden Springs area until 1898, a year after Irene's father Jay died. In that year, they moved back into Spokane where Will built still another house at 1007 West Indiana Avenue, and where he went into the retail grocery business, perhaps because of his connections at the wholesale end. He and his brother Oscar ran Lawton Brothers at 709 Monroe, which became Lawton Brothers and Churchill, and finally Lawton and Churchill in 1904. Two more children were born in Spokane, son Lester in 1899 and daughter Helen, in 1903.

Wednesday, November 9, 1904, Will's younger sister, Sarah, by then a teacher in Spokane, suffered a stroke while teaching her second grade class at Emerson School. She died at noon on Saturday at Will and Irene's home on Indiana Ave. She was the second of Will's siblings, after Flora, to die of the same cause as their father. She was just 32.

In 1905 Will sold out and headed for Fishtrap, west of Spokane, to homestead, farm and open a country store. We can only speculate about why he left the city for the countryside, but it may have been that Spokane was undergoing explosive growth and, since both Will and Irene had been farm and village people at some point in their lives, they may have wanted to return to a previous way of life to raise their growing family.

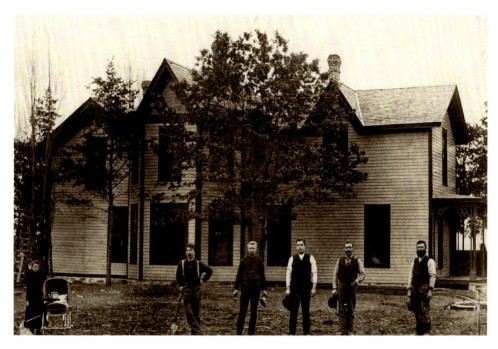

Will with one of his painting crews at a new home in Spokane, *c.* 1892. Will is in the center.

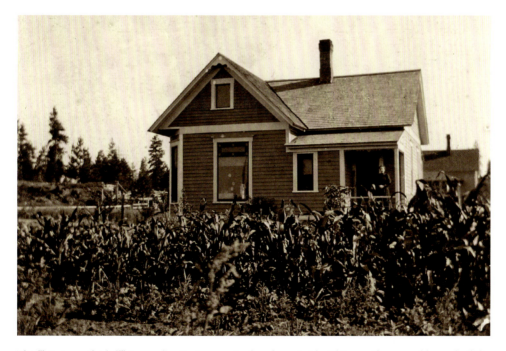

The "house on the hill" in Garden Springs on Spokane's west side. This was the second home built by the Lawtons in the Spokane area. Irene stands on the porch.

Above: The third house Will built in Spokane was at 1007 West Indiana Avenue. *Left to right:* Will, Helen, Erma and Irene. Erma was the first of the "second" family of children and was born in 1896. Helen was the third, born in 1903. This photograph is *c.* 1905.

Left: From left to right: Erma; Lester, born in 1899, middle child of the second family; and Helen, *c.* 1905.

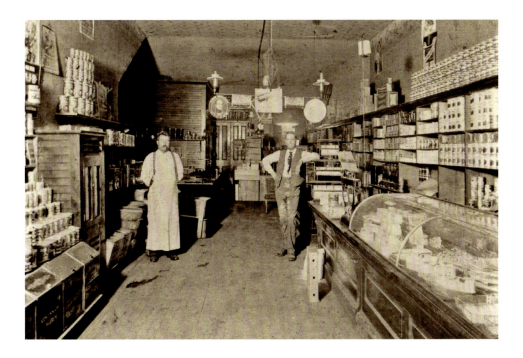

Above: Will and W. D. Churchill at their grocery store, "Lawton Brothers and Churchill" at 709 North Monroe about 1904. In recent years this property has been occupied by tattoo parlors and bail bond shops but has recently taken a turn for the better with Giant Nerd Books as the present tenant.

Right: Sarah Lawton, Will's sister, in about 1889. She was the third of the family to suffer a fatal stroke. An elementary school teacher in Spokane, she was stricken in her classroom and died at Will and Irene's home on Indiana Avenue. She died in 1904 at age 32.

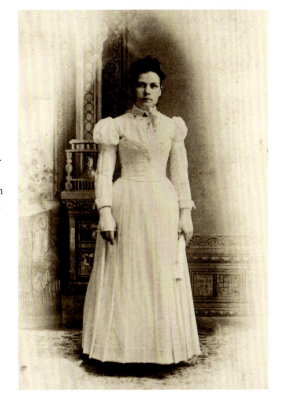

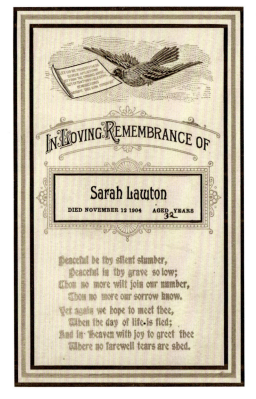

Above: Sarah's last post card to her family before she died.

Left: Remembrance card at Sarah's service.

Whatever their reasons, Will and Irene sold home and business and used the proceeds to buy land and lumber for their new enterprises some 25 miles to the west. They and their three children were moving from Spokane's pine forest, river and waterfall setting to a place where the tall pines suddenly become sparse and cede the land to sagebrush, grassland and prairie wetlands. They were also trading a well-developed city environment having the conveniences of the time, for a rude homesteader's shack having no comforts at all, at least until their new buildings could be erected and made habitable. Movement of household goods and materials for building anew was accomplished by rail and by horse drawn carriages and wagons.

The family was repeating the pattern carried on by their earlier move to Spokane and by at least two generations of Lawtons before them, as they moved west (albeit only 25 miles this time) to seek new land and opportunity. Two or three moves westward in each generation had become the norm.

When I read Will's heart-breaking account of the absent flowers at the children's graves on Decoration Day, I resolved to decorate those graves as often as I could from then on, particularly for Memorial Day. Carol, my wife, and I visit the family plot at Greenwood Cemetery at least a couple of times a year. We have missed only a few Memorial Days in the past 20 years and for a couple of those have either sent flowers or had someone go there for us. In a year's time the grass often grows over the gravestones, especially the small children's stones, so we trim it away using whatever tools we happen to have with us. We place flowers at the various markers, starting with the one for the twin brother of our son Jack, who we lost at birth, then moving to the three other children, then parents, grandparents and great grandparents, aunts and uncles, and others. There are four generations now represented there beginning in 1892 with the monuments to the two little ones of whom Will spoke so movingly, and the latest to the memory of our own child in 1970. Sometimes we also put flowers on a grave here or there of some of the many other interrelated families that came to Spokane from Wisconsin.

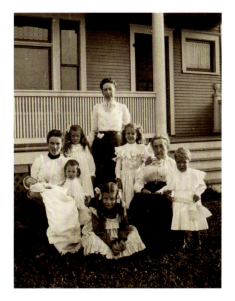

Lawton cousins, Moms and Grandma about 1904 at 1007 Indiana. The adults are Lenore Lawton, seated left; Irene, standing; and Grandma Lawton (Maria), seated right. Lenore was the wife of Oscar, Will's brother.

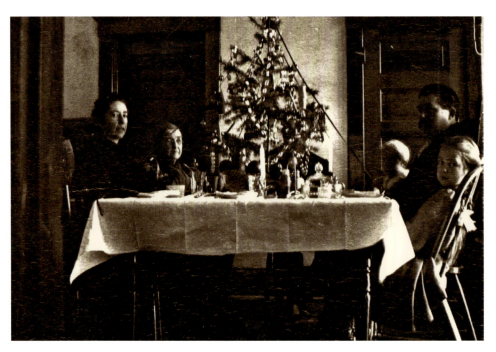

Christmas at 1007 Indiana c. 1904. *Left to right:* Irene, Grandma Lawton (Maria), Lester, Will and Erma.

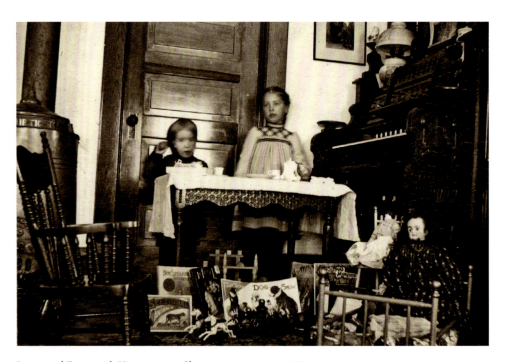

Lester and Erma with Victorian era Christmas presents *c.* 1904.

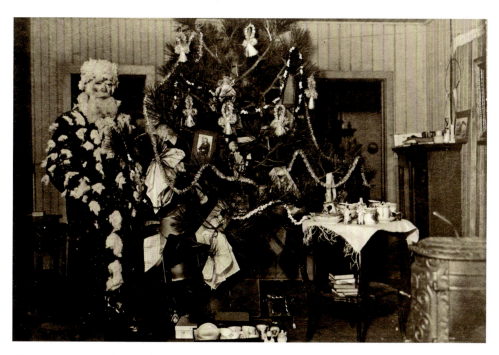

Christmas at 1007 Indiana with McCormick as Santa Claus. Although we do not know who McCormick was or his relationship to the family, he was probably a friend or neighbor.

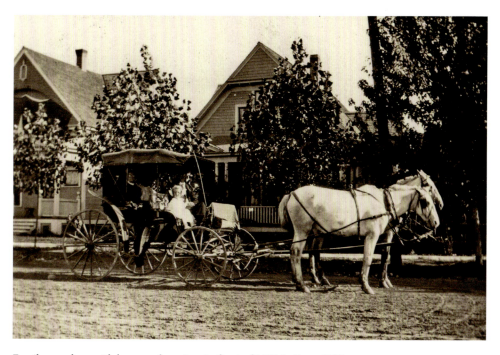

Family members with horse and carriage in front of 1007 Indiana, 1905.

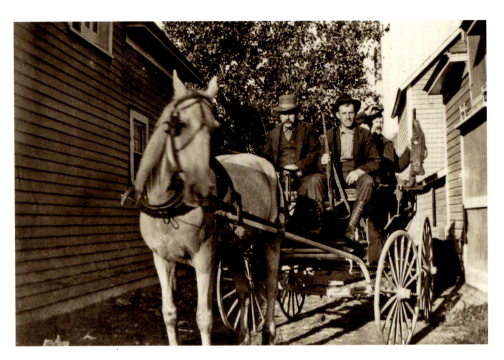

Will and friends headed out for a hunting trip in 1905.

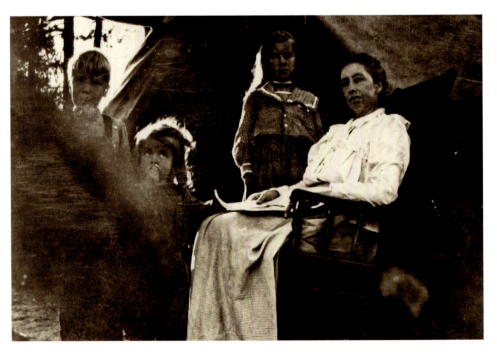

Family camping at Medical Lake in 1905. *Left to right:* Lester, Helen, Erma and Irene.

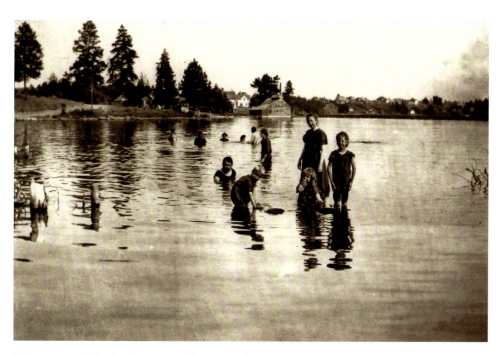
Swimming at Medical Lake, 1905. Will, Lester, Helen, Irene, and Erma. Note that the swimwear of the day resembles the "burkinis" mired in European controversy today.

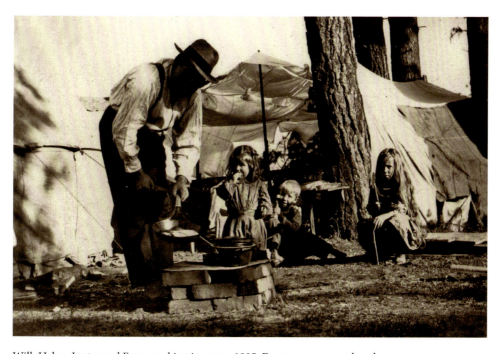
Will, Helen, Lester and Erma cooking in camp, 1905. Erma seems not to be a happy camper.

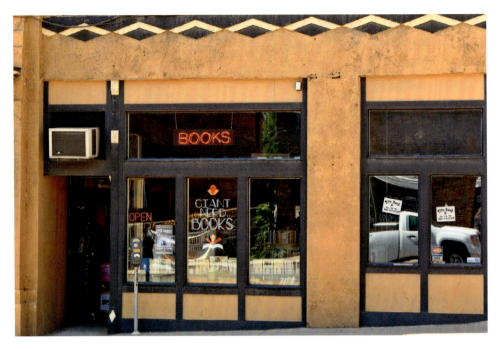

Present day Giant Nerd Books at 709 North Monroe, site of Lawton Brothers and Churchill grocery in 1904.

A peek inside the eclectic Giant Nerd Books.

PART TWO

EARTH, ROCKS AND SETTLERS:
The Flowering and Withering of Fishtrap and Lake Valley

4

A Hard but Beautiful Land

Fishtrap, Washington, was my father's birthplace. As such, I heard stories about it from the perspective of my dad's childhood and early adolescence but not much about how the family came to live at this unlikely place. My father would wonder aloud why his dad homesteaded what amounted to acres and acres of rock when there was better land not far away. On the other hand, it was also his childhood paradise lost. It was his idyllic place where he also lost virtually everything he cared about except for his mother and remaining family.

When I was a child my father would always point out where Fishtrap was when we passed it on the highway traveling to Spokane for a family Thanksgiving at my Aunt Helen's house or just for a visit. I was well aware of the place, but my interest in what it was all about from the perspective of my grandparents was awakened by the discovery of my grandfather's letters. The letters were about his home, farm and businesses and what happened there day by day. So I began with the letters and slowly built a picture of what happened there with layers of research, including tramping the land, reading Will's homestead file, and spending hours in a small local library reading newspapers of the day on blurred and scratched microfilm.

On May 6, 1912, Will Lawton penned the following lines from Portland, Oregon, where he was working as a painting contractor, to his family in Fishtrap, a small farming community in the channeled scablands of eastern Washington:

> Everything is so green every where the grass is so tall and no rocks anywhere you could hardly find enough to throw at dogs if you wanted to. It seems a pity that there are so many acres of nice tall green grass everywhere and nothing to eat it and our cows and horses have to live on sage brush and wild onions and scab rock.

On June 2, 1912 he painted a similar picture:

> It (the Willamette Valley) is all rolling hills and valleys covered with timber and small farms as far as the eye can reach. And the beauty of it all, is you can look as far as you can see anywhere you like and you cannot see a single rock.

To understand the depth of rock aversion behind this sentiment one must understand the scabrock country and the story of those who settled, and then abandoned, this most unlikely place to scratch out a living.

The channeled scablands of eastern Washington were formed some 15,000 to 18,000 years ago near the end of the last ice age when an ice dam collapsed in what is now northern Idaho, suddenly draining an immense lake which had occupied large portions of western Montana. The flood was of cataclysmic proportions. In a few days it swept through what is now eastern Washington on its way down the Snake and Columbia River Basins, past the mouth of the Willamette River, to the Pacific Ocean. This monster geologic event, together with its predecessors in a series of such events, shaped the scablands as they existed in Will's day and in the present.

Many have imagined what these floods must have been like. Sixty times the flow of the Amazon River, ten times the combined flow of all the world's rivers, 500 cubic miles of water, the amount of water in Lakes Erie and Ontario together, a wall of water 250 feet high traveling at a speed of over 40 miles an hour; these are the ways scholars have calculated to try and grasp how it must have been. As the water swept down to the sea, it formed currents, eddies, whirlpools, torrents, waterfalls, plunge pools and all other manner of water flow. These sculpted the earth and left behind the rocks of which Will complained.

As the water scoured away the rolling hills of rich soil, it left behind the underlying volcanic rock—lots of it. There are basalt rock outcroppings, patches of exposed bare rock, isolated boulders, fields of boulders, gravel bars, lava rock, piles of rocks, and generally just rocks everywhere. Nearly the only soil left was at the higher elevations, where the hills were spared. In the intervening millennia, thin soil has re-deposited itself in the low lying areas but rocks still dominate the landscape.

Will's unfavorable, or perhaps wistful, comparisons of the land he found in Oregon to that which he left in the scablands to the east, led me to spend a fair amount of time poking around the countryside to see for myself what he was feeling when he said, "this (Portland) is certainly a beautiful place to live; the soil is very fertile and no rocks in the way." And, "you can go for miles here and not see a rock except in buildings." Fortunately, it was easy for me to traverse the landscape because the U.S. Bureau of Land Management has bought up some 8,000 acres of the old homestead land and manages it as the Fishtrap Recreation Area. Except for places still used for grazing cattle, the area has been returned to its natural riparian state by filling drainage ditches and reestablishing wetlands, and is available for hiking, birding, mountain biking, fishing, and so on.

As one walks the trails, sets off across country, rows the length of Fishtrap Lake and drives the back roads, one begins to understand that the rocky grasslands have their own hard won beauty. It is far more subtle than the overwhelming, lush and easy beauty of the coastal areas. The country is broken and uneven with hills, mounds, depressions, potholes, coulees, lakes and canyons dispersed among the many rock formations. Delicate pink wildflowers the local people once called rock roses grow from the holes in volcanic rocks or from the rocky alkali patches. They are bitterroot, the roots of which were once a food staple for native peoples. Orange and yellow lichens pattern the faces of the broken basalt pillars, and wild iris and geraniums and lupine grow in masses in the spring. You might see an outsized clump of blooming wild iris in the spring that owes its proliferation to a favor granted by a passing cow.

Tall bunch grass, cheatgrass, sage brush, and occasional stands of Ponderosa pine fill out this beautiful, but often harsh, landscape. Cheatgrass is a European annual that was introduced, probably as a contaminant in wheat seed, sometime before 1900. The invader rapidly became a dominant species of grass on the entire Columbia Plateau.

In the spring you see that wet and dry are interspersed, with low wetlands dotting the dryer rocky grasslands. The cheatgrass is lush and green and wildflowers are abundant. Redwing and yellow-headed blackbirds, many species of ducks and geese, gulls, sandpipers, terns and numerous other birds and animals are abundant. As summer wears on, the beauty of the scablands becomes harder to discern. The cheatgrass turns red, the land begins to dry out and the waterfowl young are half grown. By late August the land is parched. The main purpose of late August, anyway, is to remind us that winter might not be so bad after all. By then much of the wetlands have dried up, leaving behind the lakes and the shrunken and stagnant ponds. Greens and reds are replaced by shades of gold and brown. Cheatgrass seeds have developed tiny spear points and their preferred mode of transport is the human sock. They torment man and beast alike, sticking in the fur, hide and even flesh of the latter. Fortunately, we can take a break and pick the troublesome irritants from our footwear. The animals cannot. Everything is dry and crunches underfoot and the rain doesn't come until late September or October. As the vegetation pales and recedes, the rocks in all their formations return to the forefront, matted and framed by the dry grass, soon to be covered with ice and snow.

The channeled scablands occupy a large portion of eastern Washington known as the Columbia Plateau or the great Columbia Plain. Rough boundaries of the scablands are the Spokane River on the north, the Columbia on the west, the Snake on the south, and the fertile rolling wheat hills known as the Palouse country to the east and southeast. Understandably, the channeled scablands were among the last to be settled during the homesteading period following the Civil War. The wetter and more fertile lands of the Palouse Hills to the south, were settled first since the rainfall there amounts to some 18 to 20 inches per year, while rainfall in the scablands can be as low as seven inches depending on the location.

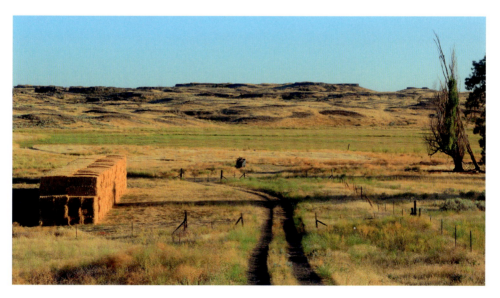

This photograph was taken a few miles west of Fishtrap and gives a good idea of what the dry and rocky land looks like.

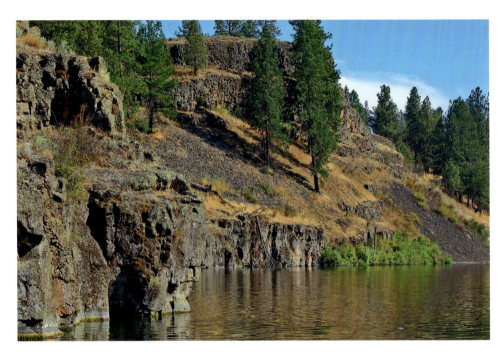

Basalt cliffs at the edge of Fishtrap Lake. Rocks dominate the landscape.

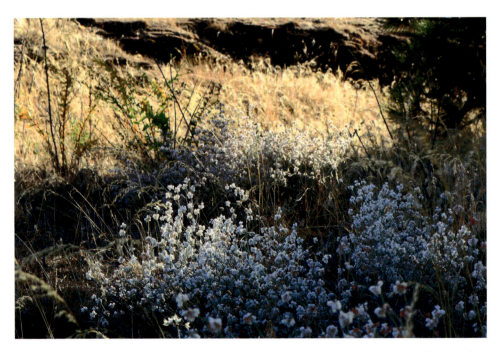

Wildflowers dried by the season. They were attractive when fresh in the spring and are still pretty when dried by the hot August sun and wind. They exist among the rocks no matter what the season.

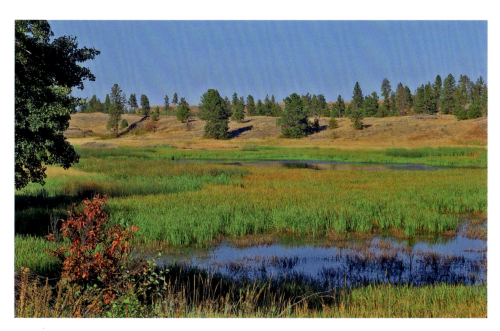

Part of an interpretive site on the old Folsom place one section south of the original Lawton homestead. The Bureau of Land Management calls this "a wetland reborn." Drainage ditches have been filled and the land is returning to its natural state before grazing and homesteading began. The Folsom property is now public land, while the Lawton place is part of a present day ranch.

Cheat grass and rocks among the aspens near Fishtrap Lake

5

They Planted and Harvested in the Harsh Scablands

In my quest to get to know my grandfather and to understand his life, I visited the National Archives in Washington, D.C. I found three records there that advanced my cause. This first was his homestead file. This file included depositions from Will and two of his neighbors giving the history of the property, other information about what had been done to "prove up," and personal information concerning his health. The homestead documents had an emotional impact on me similar to that of the letters. Much of it given in Will's own words, it was a way of hearing his voice nearly a century later as well as containing factual history for which I had no other source. I also found the "Tract Book" recording the ownership, effective dates, and locations of other homesteads nearby. Finally, I found on microfilm the history of the post office which Will established as part of his overall business enterprise there.

Most of the land in the Fishtrap area was homesteaded in the decade of the 1880s. Prior to that time, as native peoples were shoved aside, it was used for open range cattle and sheep grazing, and by white people "passing through" on the nearby Colville Road or by fur trappers and traders, missionaries, and other wanderers back to the 1850s and even earlier. Since both the Colville area to the north and the Walla Walla and Palouse areas to the south had been settled earlier than the scablands, the latter had to be traversed to get from one settled area to another.

Some of the neighbors in the Fishtrap area took up their homesteads as follows: Frank McCaffery, 1880; Ellsworth M. Thorp, 1881; John M. Brown, 1887; C. K. Brown, 1888; Thomas M. Box, 1889; Frank McGlade, 1901; Matthew M. Blunt, 1901; and Wynford Dyer, 1901. Just as the best lands to the south were already taken up before 1880, the best of the scablands were occupied by 1890. The original settlers were motivated by different things. Some settled on their 160 acre parcels with the intention of farming and making their living, while others were in it for speculative purposes with the idea of selling when they could do so profitably. Still others homesteaded quarter or eighth sections when they had other sources of income such as railroad jobs.

Another impetus to settlement of the scablands was the completion of the transcontinental Northern Pacific Railroad line in 1883. The railroad came through the area from the west to Spokane in June of 1881 and the last spike was driven where east and west met at Gold Creek, Montana, on September 8, 1883. Not only did the NP provide access to the area for the settlers, its own workers lived there as well and took part in farming and community life. The railroad provided access to markets, primarily Spokane, and transportation to points east, and west to Portland and Seattle.

They Planted and Harvested in the Harsh Scablands

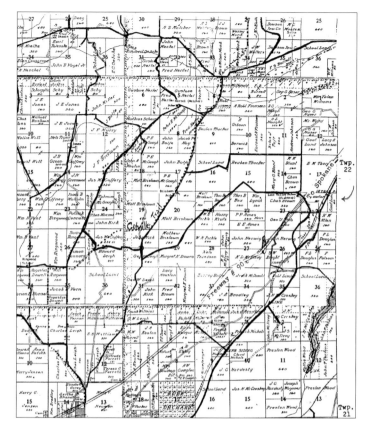

Section map dated 1911. Note that the "Freeway # 90," which came along later, is superimposed on the map. Also note the Colville Trail to the west. The Lawton property is designated by the arrow in the right margin. The Govt. Land designation near the arrow is the 80 acres homesteaded by Will. The map was originally published in 1911 by Geo. A. Ogle & Co., Chicago, Ill., under the title "Southeastern Lincoln County, Washington."

So the area known as Fishtrap and its wider community, Lake Valley, in the harsh scablands was divided into 160 acre and larger farms. This more or less worked for a while because the settlement years coincided with a wet cycle where adequate moisture was available for successful farming. Wetlands were drained for pasture, dairy farms were established, wheat and rye were grown on the fertile hills, potatoes and garden truck were grown near farmhouses, and chickens and hogs were raised near the barnyards.

But all was not well even from the early days. As we shall see, it was difficult for Will Lawton and his neighbors to make a living. Moreover, the successful farmers bought up their neighbors' places as they moved on. Of necessity, the farms began to consolidate soon after the area was settled.

Lake Valley was well within the sphere of influence of the town of Sprague, just 12 miles to the southwest. Foreshadowing Dr. Seuss by a century, Sprague began as the village of "Hoodooville" around 1872. It was later renamed for General Sprague, who was a superintendent of the Northern Pacific Railroad. The town was chosen as a division point for the NP, and it soon became a center of railroad activity, including a roundhouse and repair shops. After the railroad was extended from the west toward Spokane in 1881, the town of Sprague was incorporated in November of 1883. Sprague continued to grow until its day in the sun came to an end with

a devastating fire in 1895 that wiped out most of the town. The railroad shops were moved to Spokane, and a rebuilt Sprague had to settle for being a small commercial center serving a greater area of villages, settlements and farms, including Lake Valley and Fishtrap.

As more people came to the area, a small community began to form around the place that would become known as Fishtrap. Other than the settlers themselves, the first sign of a community was the establishment of Lincoln County School District 104, the Lake Valley School, in 1889. During its brief life it was also known as the Fishtrap School or the Box School. Having nothing to do with the shape of the building or the confining nature of being trapped in school, it probably received the latter designation when the children of Thomas and Jennie Box comprised over a quarter of the student enrollment. In the 1905–1906 school year there were seven Box children of a total of 27.

The school was the typical one-room schoolhouse common to rural areas at the time. It was served by a succession of teachers who boarded with a nearby family or upstairs at the store after it was built. There was one teacher for all eight grades, but there were sometimes as many as three teachers during the course of a year. In 1901 the teacher's salary was $40 a month and by 1910 it had risen to $65. Sometimes a male teacher was paid $5 a month more. The student population ranged from 21 in 1905 to 34 in 1908. Will Lawton was the clerk of the school district for several years beginning with his arrival in 1906. He kept track of the money and reported annually to the county superintendent of schools. In 1906 the total school budget was $527.75.

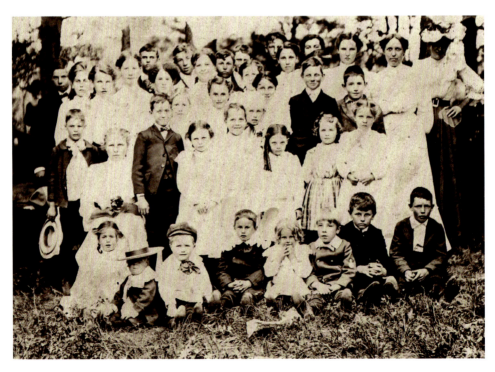

The Fishtrap school in 1906. Ethel Kingston was the teacher that year. Two of the Lawton children would be in the picture but remain unidentified.

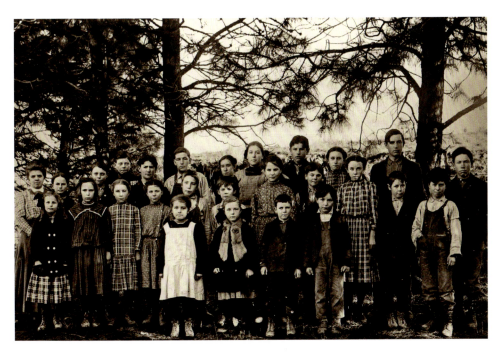

Erma's caption on the back of this postcard reads, "Fishtrap Wash. Lake Valley School Dec. 1910." Someone else had scrawled, "A bunch of mutts." Helen is in the white dress in the front row, Lester is directly behind her, and Erma is fifth from the right in the back row.

The Lake Valley School was located about a half mile from the Fishtrap store and post office on the C. K. Brown place. Inside the school were desks and chairs, a large wood stove everyone called "the furnace," and, after his assassination in 1901, a picture of William McKinley adorned the wall. A hand pump, two outhouses, a woodshed and a barn were outside. The older boys carried in large rounds of wood to feed the furnace in winter.

Will's youngest son Walter once recalled that a tough time to be in the schoolhouse was in winter when the boys rode their horses to school after a morning of chores. The gradual warming of the closed-up room from the furnace and the heat of bodies would enable everyone to relive the intensified aroma of the morning work, including horses, sweat, ripe clothing and whatever was tracked in. Teachers have always had to endure social problems; they are just different from generation to generation.

The teachers were expected to play the pump organ for performances, and a stage made from planks was stored in the barn rafters and brought in for Thanksgiving, Christmas and Easter programs. A wire stretched across the front of the school room to hold what passed for stage curtains.

On the Sabbath, the little schoolhouse doubled as a Sunday school, and the teacher was often pressed into service there as well. There was never a regular church at Fishtrap; for that, one had to travel to Cheney or Sprague. Sunday school classes were held for adults and children and an occasional traveling preacher came through and held a regular service.

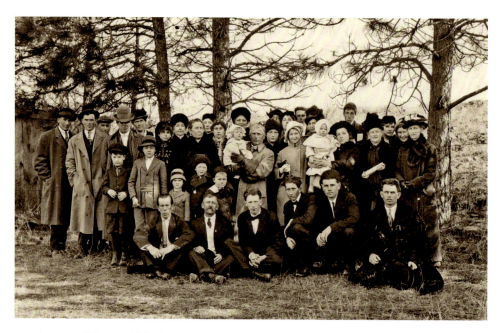

Another part of the social life of Lake Valley was the Sunday School. This photograph is from *c.* 1912. Will is in the third row back, third from the left with his ever present bowler hat, while Irene is one over to the right of Will with dark hat and coat. Erma and Lester are teenagers in the back toward the right.

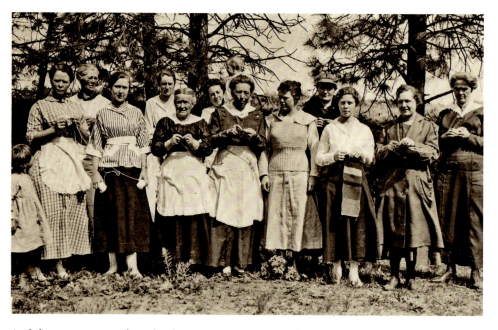

And there was a women's circle of some sort, most likely a knitting society from the looks of this photograph. Identities and date are unknown.

Above left: A child's card from the Fishtrap school *c.* 1914. Many names are recognizable from the text of this story. Mother's Day received official national recognition in 1914 so this may be one of the first Mother's Day cards.

Above right: This is the front of the picture card from school.

In 1902 the Northern Pacific Railroad established a station in Lake Valley and originally named it Vista. It was a block station and it was staffed by a station master and telegraphers. The little station measured perhaps 20 by 30 feet and controlled a "block" of track by means of a semaphore signal, located adjacent to the station and operated manually from inside the building through a "bay window" type structure. The signals were controlled through telegraph messages from station to station.

In addition to its track control function, the station served passengers, and shipped and received mail and freight. Mail service began in 1906 and agricultural products including cattle, wheat and milk were shipped to Spokane and points beyond. There were both a siding and a spur for loading purposes. Next to the spur were corrals and a loading chute. As we shall see, hauling milk from the farms to the rail station was a constant point of contention among Will and his neighbors.

Railroad employees were a prominent part of the Fishtrap community. From 1910 to 1920 the station master was Charles C. Henton. His wife, Nellie, was a skilled telegrapher and part of the railroad team. The Hentons bought Jim McGlade's place during their time in the community. Other telegraphers also lived at Vista to provide round the clock service. They lived in converted rail cars placed on the spur near the station.

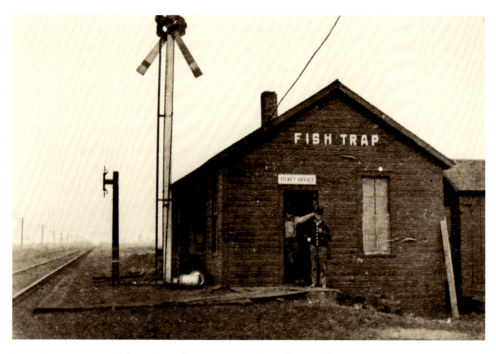

The railway station at Fishtrap located next to the tracks and east of the store.

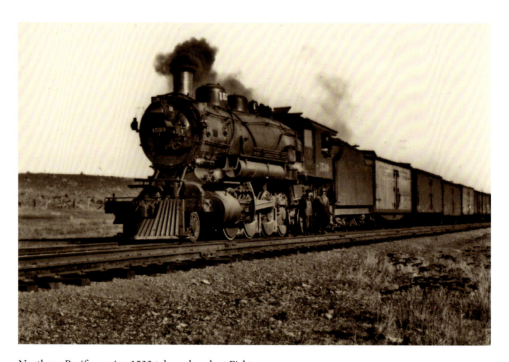

Northern Pacific engine 1533 takes a break at Fishtrap.

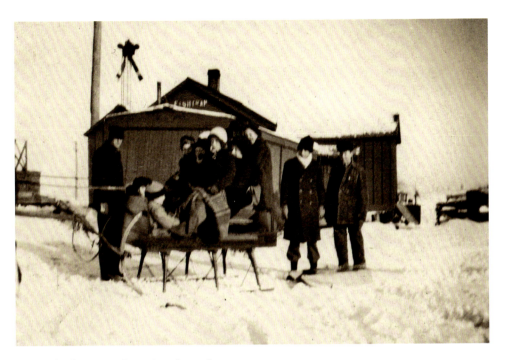

Winter sleighing near the station, date unknown.

Left to right: Mrs. Henton, telegrapher, Nina Henton, and Mr. Henton, Station Master. Probably about 1910.

In late 1905 Will Lawton made plans to sell his grocery store in Spokane and move 25 miles or so to Vista to set up a farm, country store and post office across the road from the railway station. In November he filed for a homestead on 80 acres in section 24, Township 22N, Range 39E. Under the Homestead Act of 1862 he had to pay a fee of $5.00 and live on and improve the property for five years before he could apply for a patent, or title. In December he bought an adjoining 160 acre homestead from J. P. Huffaker whose wife had died in 1903. This parcel had tillable land including a small loess soil wheat hill. But the 80 acre homestead was mostly rock and wetland with only four or five acres of farm land. He planned to make the best use of it by placing the buildings where farming was not possible. Will's homestead was one of the last in the area, with only a couple coming later, the last in 1910. It is tempting to speculate that the last one must have been solid rock or all swamp.

The year 1906 was spent planning, ordering materials, and building. Another of the homestead requirements was that residence had to be established within six months of filing. Will was unable to meet this requirement because the lumber they ordered by rail was mistakenly sent somewhere in Montana and did not reach Vista until the fall of 1906. Added to the stress of moving from Spokane and living temporarily in a homesteader's cabin, the delay must have taxed the patience of even the normally ebullient and optimistic Will, to say nothing of that of Irene and Erma, Lester and Helen, who were used to city life. The children were ages ten, seven and three, respectively, at the time. These were tough ages for confinement in a primitive cabin.

But when lumber and nails finally arrived, they went to work building the store, home, barn and outbuildings. They finally moved in on February 28, 1907. The family was active in the school during that year, and Will broke the four or five tillable acres while he was building. When they finished, they had "four acres broke, fencing, frame barn 32 × 52, dwelling and store building 52 × 56, chicken house 8 × 32, hog house 12 × 32, cellar, well, store house." On the homestead and the adjacent 160 acres, they began to grow wheat, rye, hay and garden produce; and they raised chickens, a few cows and horses, ducks and geese, and hogs.

In the fall of 1906 Will applied to start a post office, estimating that it would serve about 150 people. The post office was approved in December. The application was filed in the name "Vista," which was crossed out and the name "Fishtrap" was substituted. It seems that Vista was already the name of a post office in Grays Harbor County, and Will had to come up with a new name. He chose "Fishtrap," after the nearby lake having natural formations where the Indians once trapped fish. Then Will persuaded the railroad to change the name of its station and the place was known as Fishtrap for the rest of its existence. There is no recorded reaction of neighbors to this sudden place name change. Vista to Fishtrap may not have met with the approval of everyone, since today we know it would be a *casus belli* in most communities with which we are familiar.

Mail service between Fishtrap and the coast was reliably one day; the passage of a hundred years is not correlated with progress in every endeavor. Mail was artfully thrown from moving trains so it would land near the right spot for pickup and removal across the road to the post office. Departing mail was put on a mail crane next to the tracks where it was picked up as the trains went by.

The Fishtrap store was a center of community life. In the early years, any day could have seen five or six teams and wagons hitched haphazardly around the front or in the adjacent barnyard.

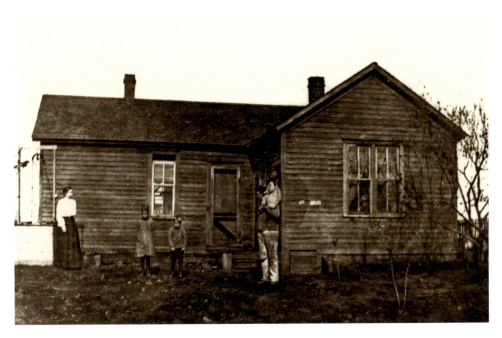

Left to right: Irene, Erma, Lester and Will and Helen at the homesteader's cabin used as temporary quarters when they first moved to Fishtrap in 1906.

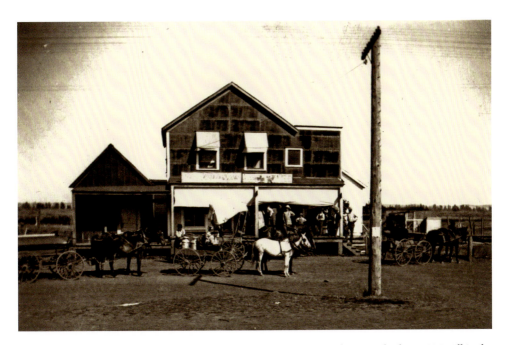

The Fishtrap store, home and post office in their heyday about 1910. They were built in 1906, still in the horse and wagon era, and soon made the transition to the automobile age.

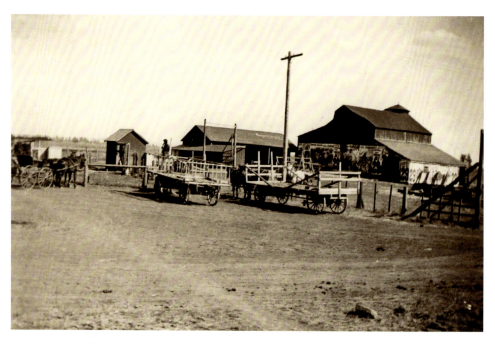

The barn and outbuildings for the farming part of the operation at Fishtrap were located immediately to the west of the store.

There might have been a buckboard or two, a couple of farm wagons, the milk wagon and a water wagon. Later on, cars or an occasional truck, mixed with the horse drawn vehicles.

Two or three or a half dozen people might have been on the covered porch that ran across the front of the store, talking, entering or leaving with the bang of the screen door. In the summer, awnings hung below the eaves and sheltered the windows of the rooms upstairs. The breeze billowed and rippled the curtains. Awnings took the place of trees which grew slowly or not at all in the hot, dry summer climate. A walk and a tiny lawn were planted on the southwest side of the house.

The store, post office and home were in a two story wood frame structure with a pitched roof, with the upper right corner squared off with the western false front of the day. The porch had a wood railing with steps on either end. The oil shed was attached on the northeast or left side of the store. In the early days of the automobile, one barrel of oil was kept in the shed, and if you needed oil that's what you got.

The store served several purposes in the community. In addition to providing goods for sale as any store would, it also provided a marketplace for local products. Local butter, eggs, and garden produce were sold there. Will also helped make the Spokane market accessible by hauling and shipping milk and other farm products. The milk was picked up early in the morning by team and wagon and shipped to Spokane on an early train. He also shipped grain in the fall.

Store and post office together were also a gathering place; they were a social center where neighbors could swap news, gossip, and complaints about the weather. Smoking, chewing

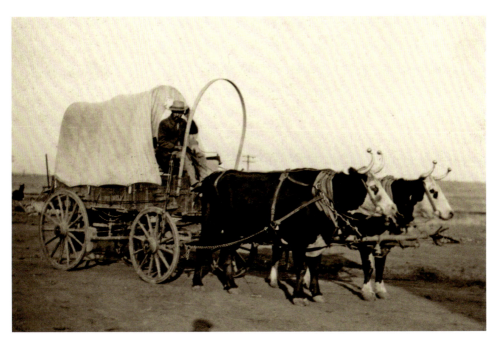

Will tips his hat while driving a team of oxen about 1910.

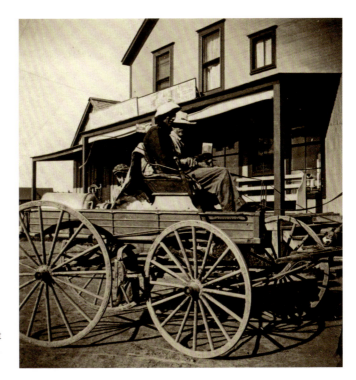

A young customer peeks out from behind a buckboard in front of the store.

and spitting would have been relegated to the porch or further out since Will and his family indulged in neither tobacco nor alcohol. The store was also a place for train travelers to stop and regroup before departing, and again when arriving back home.

Before Will and his family showed up in 1906, Lake Valley consisted of homesteads, the railroad station, and the school. The farmers and railroaders had to slog the 12 miles to Sprague, or to another nearby settlement, or even take the train to Spokane for necessities. Will made the place into its own community by adding a store, inn and post office to what was already there. As well as hacking his own farm out of the rock and sagebrush, he provided a local market for farm goods, and helped farmers sell their products in the Spokane marketplace. It worked as long as the rains came and farm prices held steady. But it was never easy.

The other requirement beyond rain and farm prices was Will himself. Without his energy, array of skills and entrepreneurial spirit, the area would have remained a collection of isolated farms that atrophied long before they actually withered away. Sadly, it would not be long before Will and his many talents were no longer present and the rains would fail and farm prices would plummet.

The resort at Fishtrap Lake, part of the social life of Lake Valley. The house was built in 1912 and the rest of the buildings after that. This photo is from the mid-teens.

Another view of the Fishtrap Lake resort. The building at the right-hand corner of the house as you face it was the original dance hall. It was damaged in a flood and replaced sometime in the 1920s.

Ladies in their Victorian finery enjoying the boating scene on a Sunday afternoon, *c.* 1915.

6

Stresses at Fishtrap—1912

Until I began to read and understand my grandfather's letters, I had never heard of our relatives, the Cook family. John Cook was Will's brother-in-law, married to Irene's younger sister Alice (Bump) Cook. Alice had come with the family to Spokane in 1890 with her and Irene's parents, Jay and Lottie Bump. John and Alice lived in Portland, Oregon, where John was the construction superintendent for a new hotel at the edge of the downtown area. When Will went to Portland in April of 1912, Alice had died from congenital heart disease the preceding November, leaving five children motherless. Because of his connection with John Cook, Will had the opportunity to ply his old trade as the painting and decorating contractor for the new Mallory Hotel. This meant three months away from family, home and business but it also meant an infusion of badly needed cash. While in Portland Will stayed with John, his children, and John's recently arrived sister Georgina. Will and John's mother-in-law Lottie Bump was also there following Alice's death. Lottie arrived first and then came Georgina to try to help care for the children, including two-year-old Mildred Cook.

Will's daily exchange of letters with Irene back home dealt with daily life at Fishtrap as well as his work at the hotel and observations of the Portland scene, including the Cooks' family life. Unfortunately, Irene's side of this conversation did not survive. I do not really know why, but I suspect that Irene, being a private sort of person, purposely failed to save her own correspondence but could not bear to dispose of Will's. Valuing privacy like my grandmother, I know that's about what I would do if I were in a comparable situation.

In late April 1912, Will left Irene and the family, and the store and farm in Fishtrap to begin his contracting sojourn in Portland. To catch the train, all he had to do was walk through the store from the living quarters in the back, out the front door, and across a dusty road to the station a hundred yards away. There to see him off were Irene, four-year-old Walter who was born at Fishtrap in 1908, and Will's uncle, Jay Lawton, who had recently moved to Fishtrap from Wisconsin. Will and Irene's other children, Helen nine, Lester thirteen, and Erma sixteen, would have been in school. The older two were going to school a few miles away in Cheney, staying with their Uncle Oscar and Aunt Lenore.

Before he left, Will would have given final instructions to the hired hands. Lena worked in the store while Davis and Rosco labored on the farm. Rosco was near Erma's age and had to be prodded to keep working. Davis was older and steadier, probably in his forties, although he apparently had his limitations as well.

When Will reached the station he bought his ticket from Mr. Henton. After saying his goodbyes, he boarded the train with his single suitcase, for he was a light traveler, found his seat, removed his ever present bowler hat, which was the fashion of the day, and settled in for the journey across the scablands to Pasco, then down the Columbia River Gorge to Portland.

As he left, Irene could not help worrying about Will's health. Just a couple of months before on February 15, he had suffered what was then called a "paralytic stroke," or "hemorrhage of the brain." He had intended to make the final proof for his homestead land on March 5, 1912, but had to delay the required paperwork for several weeks because he could not travel the 12 miles to Sprague to finish the paperwork. As we have seen, strokes ran in Will's family—probably the result of hypertension—easily controlled today. By this time, his father and two sisters had died prematurely of the same cause. It is a remarkable indication of the man's strength and determination that he set out on a new venture just two months after this traumatic event for which there was no real treatment at the time. Moreover, he had to be acutely aware of the ticking time bombs that he and his brothers and sisters carried around in their heads.

What could have been his motivation for taking the risk of going to a new job in Portland just two months after suffering a serious stroke? We can make an educated guess that the need for cash to keep life in Fishtrap going was substantial and never ending. The Portland work was obtained through his brother-in-law and he did not have to go back into his old business permanently to make it work. It may have seemed like a fairly easy way to get some financial relief. Still, the risk was not insignificant and he must have been well aware of it. If this is right, it would point to the severity of the cash flow problem.

Not surprisingly, his health was a theme, although mentioned infrequently, in his letters. On April 30, he reported that he was feeling better than any time since he left home. A few days later he went into more detail. "I have just got home, have been feeling fine today, think I shall feel like myself again, have had quite a time with my head. There is a lump swelled up on the back of my head about as large (as) a hens egg split length ways in the middle. It has been very sore but is much better now. It is where I had so much pain in the back of my head before I got my glasses. The other side swelled up some but not so bad. I can sleep better at night now." On May 6, he noted that his head did not bother him any more as long as he was careful. Will did not say much more about his health except to note the distances he was walking, the gradual reduction of swelling in his legs, and the continued improvement in his strength.

Health was not Will's only worry. Apparently Irene had some problems with impatient customers on May 20. Will wrote back advising her not to get excited about it as "these farmers have all kinds of time and they never hurry especially when it comes to paying their bills." This seemed to be a continual problem. Gilson had not paid his bill for a while and needed to be billed again—about the time he would get his check for selling milk. Frank Smith's bill was unpaid and he was about to die, stimulating thoughts of how to get the money out of his estate. Will Camron was put on cash or trade for firewood only, since the store needed the wood. Mark Bogle became angry when confronted about his bill, but "it don't matter if Mark Bogle is mad. I intend to get right after some of those fellows when I get home, and I will make some of them mad to stay if they don't pay up better."

And so it went. Fred McCabe was put on cash only, and was denied the land he wanted from Will for a building project. Will advised, "If he gets mean, set Uncle Jay on him. He will

make short work of him." McCabe had just lost all of his money drinking and making a bad mortgage investment. Gilson was in arrears not only on his store account but also had not paid anything on a piece of farm equipment for which he owed $150. Will at least had a signed note on that so he would get paid when Gilson's place, which was up for sale, finally found a buyer.

The milk route was also a source of worry and contention in Will's absence. Among his several small enterprises, he operated a route to pick up milk from the farmers by team and wagon in the morning to get it to the morning train to Spokane. He charged a fee for this service and it represented a steady source of income. It must have been successful, because Mr. Henton and others were often trying to cut in on Will's milk run territory. Apparently the quarrelsome Gilson thought the fee was too much and made threats. "Tell Rosco to go right along with his work on the milk route and pay no attention to Gilson. Do the work right and let him sputter. If he wants to dump his milk out let him do so. I don't think he will though." Will and Irene discussed ways to take on more customers and Will pledged to reconstruct the route to make it more profitable when he got home.

Will and Irene also spent a lot of time, ink and postage discussing the buying and selling end of the business. Everything from sorting potatoes, preserving meat, selecting the best source of butter from among the farm women, to buying and shipping chickens to Spokane markets, was discussed. No detail was too small to be considered. Will reminded Irene to weigh in the chickens there before shipping, because shrinkage would reduce the weight from 100 pounds to 85 by the time the shipment arrived in the city. They even talked about selling their old team of horses. "If you can sell them I can buy one young horse and that will be all we need for our work and one less to feed. I want something that can stand the road better than the old team."

Since Will was away at spring planting time, he also relayed instructions through Irene to the hired hands on issues of plowing and sowing. He devoted a fair amount of time and space to instructions such as he did on May 9, "Have Davis put in oats on that ground by the old well no matter how late it is. And if it don't make hay it will make some feed for the cows in the fall. It will make hay if it is planted by July 1st." Or on May 10, "have Davis mix the rye and winter wheat. Order two more sacks of winter rye from the Juland Seed Co. I think that will be enough then he can mix the wheat through all of it—that will make it about ¼ wheat. Have him begin plowing as soon as he can; before it gets too dry." One can imagine the trials of long distance farming for everyone: Will remembering things to do piecemeal, then wondering if they would get done, Irene stuck in the middle, and poor Davis dreading each day's mail delivery and the next set of chores.

Then there were the personal reminders, Irene again in the center of it. For the apparently fearsome Uncle Jay who had been mentioned for possible bodyguard duties, "Tell Lena to try and keep Uncle Jay good natured if possible. Give him an extra piece of pie once in a while. Or something to please him." Uncle Jay's photograph, with scowl and full beard, make him look as fierce as his reputation conveyed by these few brief lines. And for hired hand Rosco and daughter Erma, "Try and get Rosco to stop some of his foolishness and help Davis with the weeds in the afternoon." Just the week before he had warned, "I wouldn't let Erma and Rosco run around nights, for I don't think Rosco is very good company for her, and there is no need of their going and keeping you up later. Make them go to bed and take their rest so they will be good for something in the day time."

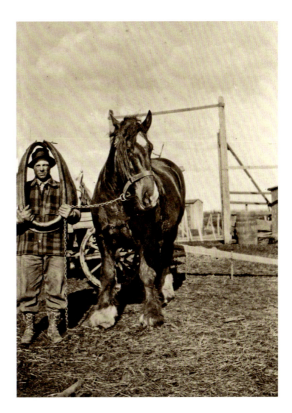

Right: Davis, Will's hired hand, self-framed in a horse collar, with Dick or Fannie, we are not sure which, *c.* 1912.

Below: Lester, four-year-old Walter, youngest of Will and Irene's children; and Davis, with bass from Fishtrap Lake. Walter was born in 1908, one of just two children to be born at the home and store at Fishtrap.

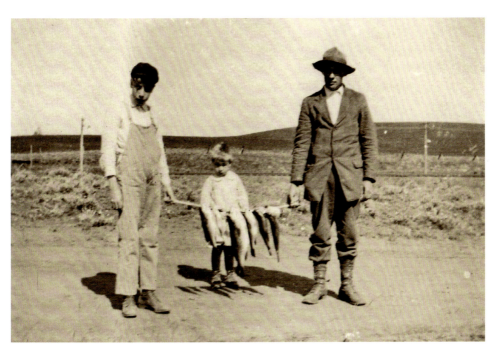

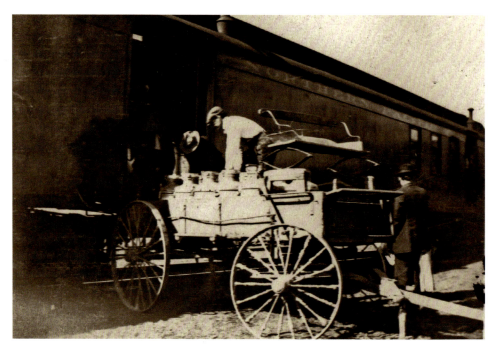

Roscoe unloads the product of the milk route into the morning train under Will's watchful eye.

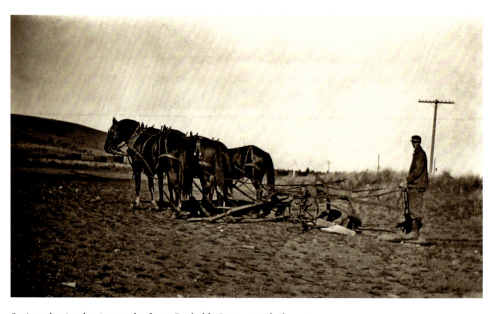

Spring plowing begins on the farm. Probably Roscoe with the reins.

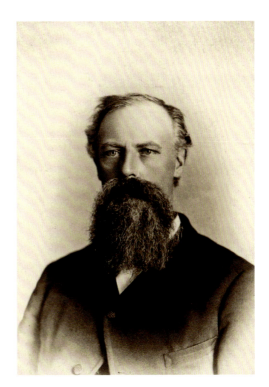

A photograph of the apparently fearsome "Uncle Jay" (Jay Lawton, not to be confused with Jay Bump) whom Will threatened to unleash upon non payers and other miscreants during his absence.

Will was an attentive father and leader of the extended family. A family story, probably reflecting some truth, suggested that Will was so traumatized by the loss of his first three children that he habitually overfed everyone, often to their long term detriment. In any case, family concerns were a thread never far from the surface in his letters.

In contrast to the worries and the focus on details that characterized his writing about the home front, Will was expressive and sentimental about his new environment and the loved ones he sorely missed. We have already seen his wonderment at the lush coastal ecology compared to the far more sparse and spare and subtle environment at home. He often marveled at the beauty of the trees, "There are some of the most beautiful natural groves … that I ever saw. Fir trees! Not large; but about right for nice shade trees. And scattered among the Firs are a wild nut tree about the size of fir trees and they are full of blossoms about the size and shape of wild roses only they are pure white. They are the most beautiful sight I ever saw in the shape of forest trees." There are many such poetic descriptions.

As for the home folks, of course he missed Irene the most. He signed most of his letters and cards "Love from Papa," and when invited to a church social he said:

> [T]he men's social club of the church have a meeting in the church parlors. It is a social affair, I should like very much to go. But (the pastor) said that the men were to bring their wife or sweetheart. But as my wife is so far away and she is the only sweetheart that I ever had, I don't see how I can go.

Will often described various aspects of his work on the new hotel. The passage below says everything about it that needs to be said:

> I wish you could see the ballroom that we have finished today. It is beautiful. It is decorated in shades of pale green and white and gold. Perhaps I will take you to one of the swell balls there sometime. We are working in the lobby now that is done in grey and white. The dining room will be done in old ivory and white. The woodwork all through the rooms in seven stories is white enamel, with mahogany doors, and cream colored walls and skimmed milk ceilings. There are 210 sleeping rooms. Well I must stop and go to bed.
>
> Goodbye with love, Will

Besides Irene, Will seemed to miss four-year-old Walter in particular. He was the baby of the family, born at Fishtrap when his father was 45 years old. His second letter home, on April 29, was to Walter:

> Dear Walter,
> I have got home from work again. It has been raining all day. Do you get any rain there. It rains here almost every day but not hard just a drizzle … How are the little chickens getting along? Do you feed them good? You must see that Fannie's colt has good care so that it will grow. I'm feeling pretty well now. My work is not hard. I get home about 5 OClock. Goodbye.
> Love from Papa

Will wrote cards to the older children as well, but only Walter got a promise of a watch when he got back home.

As I read and understood the letters, I wondered what hotel Will was working on and if it was still standing. Portland was familiar to me because I grew up in the Northwest and because our son Matthew attended Portland State University and lived there for several years. My mother thought the hotel was the Multnomah, and as I soon learned, the remaining Cook family thought so too. But it could not have been the Multnomah, because that hotel was in business during the spring of 1912, advertising its charms frequently in the *Oregonian*. This was the time when Will's hotel work was still in progress.

Since the first time I visited Matt at PSU, I had stayed at the Mallory Hotel. It was near where he lived, it was affordable, and it had a warmth and charm that came from its many reminders of the past. Will left a few clues including the color scheme and its approximate location near West Sixteenth. One evening I was discussing the hotel with Matt and he said, "It has to be the Mallory because it is the only hotel up there...." The pieces began to fall into place and I began to believe he was right, although I still thought it might be the Multnomah.

Then I called the owner of the Mallory at the time, Albert Gentner, who said he didn't know much about the history of the hotel except that it opened in July of 1912. That pretty much clinched it when I considered the opening date with Will's descriptions, the color scheme, and the location. I further confirmed it with newspaper research and through a visit to Mr. Gentner who showed me the original blueprints for the "decorations," which were ornate wall designs applied by stencil.

The Mallory Hotel at the edge of downtown Portland, Oregon, opened the first week of July, 1912, just after the Rose Festival and in time for a national convention of the Elks Lodge. During its first week it took in "transient" guests and began taking regular reservations the week following. Since 2006 the Mallory has been the Hotel de Luxe. It was added to the National Register of Historic Places in 2006.

Street scene downtown Portland in June, 1912. On June 10, Will wrote, "The Rose Fair started today but I have not seen anything of it except that the city is decorated something wonderful with flags and bunting. They will have an electric parade tomorrow night, think I will go see it if I can find enough room on the street."

After staying at the Mallory several times over a period of a few years, I finally had it figured out. I felt a little like my wife Carol's Uncle Tony when he visited us in Washington, D.C. years ago when we were students there. He was driving down Pennsylvania Avenue looking for our place on "I" Street when he rolled down his window and hollered at a cabbie, "Where's Pennsylvania Avenue?" Whereupon the cabbie shouted back, "Who's buried in Grant's tomb?"

For a year or more I had been staying at the Mallory every so often; the answer was right in front of my face and I did not see it. At the time, the color scheme was still green, gold and cream color; the size and location fit; and it had a comfortable, inviting feel that I could not really explain. I just wanted to be there. I still cannot believe I missed it for so long, but it is not the first time I have blown past the obvious, lost in my own fog, and it probably won't be the last.

The Mallory as it appeared in about 1996. The architect was a Dutchman named Hanselman, the construction superintendent was John Cook, and the painting and decorating contractor was John W. Lawton. Its style might be described as early twentieth century eclectic with Renaissance Revival and Classical Greek influences.

The Mallory hotel at street level *c.* 1996. Apparently it was built as a speculative venture because it was still advertising in the *Oregonian* as late as June 22, for an "Up-to-Date Hotel Man or Capitalist" to furnish and operate it.

The Mallory hotel interior as shown on a postcard handed out by the hotel in the 1990s. At that time, it appeared much as it did when Will finished his painting and decorating job. Although it must have had new carpet and been repainted several times, the basic ivory/white and green and gold color scheme were retained into the early 2000s.

The writing side of the same postcard.

7

Strains in Portland—1912

Tucked into the bundle of letters from my grandfather to my grandmother were two more letters. They were from my great grandmother, Lottie Bump, to her daughter Irene. They were also written from Portland, where she was helping to care for the children of Alice Cook, her daughter who had died recently. My great-grandmother's voice was another channel that sharpened my insight into my grandparents' lives and helped fill in the details of a pretty good story besides.

During his stay in Portland, Will not only worked with John Cook on the hotel project, but he lived with John's family as well. He paid $4.00 per week for his room and $1.50 each week for his meals. During his stay there he was a perceptive observer of Cook family life. He and Irene would have been more interested than usual because of Alice's recent passing, which left five children, ranging in age from two to twelve or so, motherless. Will relayed his observations concerning Alice's brood to Irene. Of particular concern was two-and-a-half-year-old Mildred. On May 28, Will wrote:

> I guess Mother is getting homesick. Mildred is a great trial to her and she (Mildred) is getting meaner than the seven year itch. Her Grandma is a slave to her and I think the quicker they are separated from each other the better it will be for both of them. Georgina gets along with Mildred fine and will make a much better girl of her. She is very badly spoiled. [She] has entirely too much attention. Georgina makes the children mind without much trouble and when she speaks to them they know that they have to mind. And that is just what they need. Mother thinks it is pretty hard for her (Georgina) to be so strict with them. But I think it is for their good. They have fallen into good hands. And it makes them a great deal worse to have their Grandma interfering in the government of them.

John William Cook was born in England in 1874. He was one of eighteen children, twelve of whom survived into adulthood. His father, John L. Cook was a stonemason who migrated to America in 1883 and sent for his family the following year. The elder John Cook worked in Minneapolis and St. Louis until 1889, when he, like the Lawtons and the Bump family, answered the call of Spokane during the post-fire building boom.

John Cook and Alice Bump were married in Spokane on December 28, 1898. They moved to Portland in late 1910 or early 1911 with their five children to work on the hotel project. John's parents and some of his younger brothers and sisters also lived in Portland at the same time.

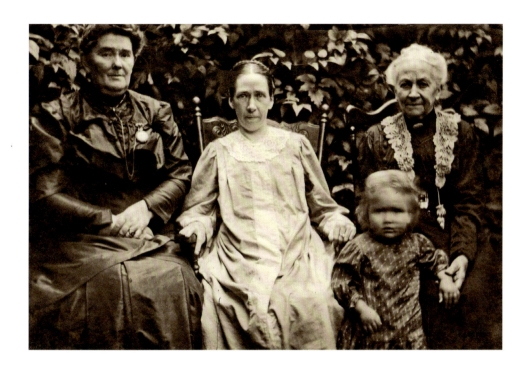

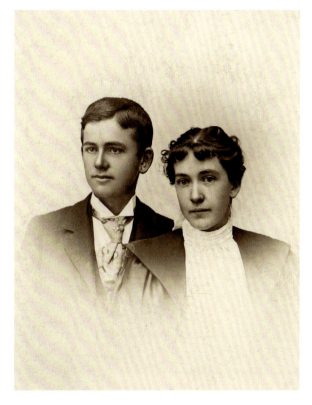

Above: Left to right: this is a photograph of Mrs. Cook (John Cook's Mother); Alice (Bump) Cook; Mildred Cook, John and Alice Cook's youngest child; and Charlotte (Lottie) Bump (Alice and Irene's Mother) in 1911 just before Alice's passing.

Right: John and Alice Cook *c.* 1898.

Alice had been frail and ill for some time. She had a congenital heart condition and the strain of bearing and caring for five children probably did not prolong her life. During her final illness, she was waiting for the arrival of a heart specialist from back east, but she died before he got there. Alice's passing put the family under great strain, which must have been magnified by narrowly missing the hope offered by an arriving specialist. One of the causes of stress was the tug-of-war between Grandma Bump and Georgina, which began over the younger children, Mildred and her brother Kenneth.

The children's Aunt Georgina Mae Cook was a young widow when she came to help care for Alice and John's children. She had not been married long when her husband died, and she had already settled into some spinsterish ways by the age of 27. As Will observed, her firm approach with the children seemed to work. But it also seemed to require John's presence to take the edge off. And the strife was probably made worse by Grandma's interference and the palpable dislike between the two women. Grandma expressed a few pungent opinions on the subject in her letters to Irene.

> (It) is something awful this morning. Geo. Has got her back up about something I don't know what unless I laid abed too late. Last week she wanted me to tell her when she got ready to pack, which were Ali's things, but today she is getting ready and sorting things and not one word to me about anything. I often wonder what I have stayed here so long for but it seems that it was to be. Gio and I have not a thot in common; she thinks I am a mere school girl in wisdom.
>
> Yesterday she had the boys get 25 snails and it leaked out later that they were sent to Mrs. Cook's (John's mother) to make medicine for the children to take for hooping cough. Of course, I had to express my opinion of such filthy stuff and she appealed to John at night and he objected so the medicine is nix. I feel as though the children are going to drift from their mother's people and the prospect is not pleasant for me, but I must not spend my time writing for the boss expects a lot of patching done. She has just sailed up the street, errand unknown to me.

Later that same evening of June 7, she added, "I am as tired as a work horse but (do you) suppose anyone thinks I have done anything."

By this time Will had moved to a rooming house closer to the hotel because John and family were preparing to move back to Spokane to get Georgina and the children settled in Spokane before he left for Chicago for another construction project, this time a large cathedral. He intended to come back for the children as soon as he became established there.

But John Cook abandoned his family and he never came back. The children were left in Spokane for Aunt Georgina to raise and her well-oiled disciplinary machine fell apart. One day about a year after the family moved back to Spokane, Grandpa Cook stopped by Georgina's house to see how things were going. Chaos reigned with one of the boys locked in an upstairs bedroom, little Mildred locked in the cellar because she wouldn't take her medicine, and Georgina yelling at the rest. After Grandpa got it sorted out he said, "This is enough, we're not going to do this anymore." And the children went to live with Grandpa and Grandma Cook who were nearly finished raising twelve of their own.

Mildred and the boys were raised in Spokane by their Cook grandparents, with the help of various aunts and uncles because there were plenty of them around. Mildred went to live with her

Above left: Two-year-old Mildred Cook *c.* 1911.

Above right: Another photograph of Mildred in 1911.

Uncle Sam and Aunt Cora for a while when she was about fifteen, but soon thereafter Aunt Cora ran off with a religious cult after hocking Mildred's mother's silver, and Uncle Sam was devastated. Then Mildred went to live with a high school friend and after that she was more or less on her own.

After her father left for Chicago, Mildred only saw him three times. He visited Spokane once when she was about five, she had lunch with him at Spokane's Victoria Hotel when she was about twelve, and she visited him once after he had moved on to Flint, Michigan, when she was a young woman.

Although John Cook was an indifferent father, he did support the children financially. Over the years, Mildred often wondered why her father never came back for them and what he was thinking to abandon, emotionally and physically, five children who had so recently lost their mother. The only answer she ever came up with is that he just didn't know what to do with five children. Fathers were not often close to their children in those days and "maybe he just didn't know what to do…"

As their Grandmother Bump had feared, Mildred and her brothers, for the most part lost touch with their mother's people. Mildred was allowed to go to Fishtrap once or twice and she was permitted to go to her Aunt Lillian's (Alice and Irene's other sister) two or three times. In later years she became friends with her Aunt Irene and her cousin Helen. But beyond that, although they were nearby, her growing up years did not include her mother's side of the family.

Mildred Cook (Betty Angel) at about age 16 *c*. 1925.

Grandma Bump's account of her tussle with Georgina begs the question, "Really? Medicine made of snails to cure whooping cough?" A quick internet check reveals that, indeed, snails have been used since the time of the ancient Greeks to treat respiratory and other ailments. Such treatments continued into the twentieth century and research into the subject still goes on today. The English and the Scotch, in certain areas, were particularly keen on this form of therapy. Given their penchant for black pudding and haggis, it sort of makes sense. There were different preparation methods, including crushing snails in a mortar with a pestle, then straining the resulting mess and mixing it with various sweeteners. Another way was to use a salt solution to float, then skim the mucous, and mix that with sweeteners. Whether one then takes it "neat," like bourbon, is unknown. There is no need to elaborate further; the imagination can do whatever else is left to do.

The question remained, "whatever happened to the Cook family, especially Mildred?" I had figured out who they were through a genealogy left by my Aunt Helen. But to learn something about the Cook family story was another matter, since I imagined they disappeared into the Midwest, and with Cook being a fairly common name, they would be hard to track down. From the letters, I had no idea who Georgina was; I thought she might be John's new wife. The only ones with the probability of being still alive were Mildred and Kenneth; and I figured that even if they were, finding them would be unlikely at best.

On Memorial Day weekend in 1996, I went to Greenwood Cemetery in Spokane. On the way, I stopped at a store and bought several bunches of flowers and some large cups to put them in. When I got there, I parked the car near the family plot and began arranging flowers

to put on the graves, first the children's. I was inspired to do this by the poignant lines in the May 30, 1912, letter about the little ones' graves having no flowers. When I was finished I began to look around, because I had an idea there must be some related families nearby, but I didn't know who or where.

Meanwhile, two older women, who carried their years well, parked their car a few yards behind mine and put flowers on some graves nearby. One of them called out to me, "Hello … are you one of my relatives?"

I said, "I don't know, it depends on who you are."

"Well, my name is Betty Angel, but I was born Mildred Cook."

Taken aback, I managed to blurt out something like, "I know a lot about you. You lived in Portland when you were two years old, and my grandfather lived with your family, and he and your dad worked on a hotel there and …"

Betty began to look a little like she was seeing a ghost and said, "I know we lived in Portland but I don't know much about that time or any of my early childhood."

We began to exchange information, she explained who Georgina was. I filled her in on the Mallory Hotel; her family also said it was the Multnomah but she figured it couldn't be. I explained who I was and which family I'm from; she told me about her brothers including Kenneth who was still alive at the time, and so on and on. We talked for a while longer that afternoon and visited several times after that when we were in Spokane. I also gave her copies of the letters, which I happened to have with me. I helped her put flowers on her mother's grave. We became friends and she was the source of most of the information on the Cook family. At one point she told me, "I can die now, I know what happened in my early life."

Betty said she had been coming to Greenwood for years, and had always hoped to meet someone from the family, but had been disappointed until then. Our paths overlapped by about five minutes in a year's time and somehow we managed to connect. Betty lived her life in Spokane. In 1941 she married Gardner Angel and for many years worked as the pastry cook at Wilson's, a popular local restaurant. Later she worked at the Crescent Department Store. Her husband died in 1981 after a 40 year career as a Spokane firefighter. Betty passed on in 2000, and is buried beside Gardner in the Cook family plot, which is only a few yards from the Lawton family area. Also in these two plots are Betty's brothers, her mother Alice, and other family of Alice (Bump) Cook, including Betty's grandparents, Jay and Lottie Bump. Ironically, she rejoined "her mother's people" in death, something just as her grandmother had feared, she mostly missed in life.

John Cook lived the rest of his life in Michigan, he remarried but had no more children. He continued in the building business, built a palatial home, lost much of his money in the stock market in 1929, kept enough to begin again, and died in 1934.

In 1918 Georgina and her parents moved to Detroit. She ran a beauty shop and became a successful wig maker. She never remarried. In later years her severe personality moderated. She loosened up, enjoyed life, and, according to Mildred, became the kind of person who would impulsively "turn a somersault on your living room rug." For a while Georgina turned to Christian Science and later took up theosophy. She died in 1961.

How does one explain my chance connection with Betty Angel at a time when I needed to find her to understand my own story? I needed to connect with someone who not only had

a common name, but an entirely different name from the one I was looking for. She could have been 20 minutes earlier, or neglected to tell me her original name, or failed to make her presence known, and we would have missed. There are many possible explanations including the hand of the Almighty, guidance from those who have crossed to the other side, cosmic synchronicity, and so on. The only evidence for any of this is that these kinds of things seem to happen from time to time regardless of one's religious faith or belief. They happen in the lives of people of many different faiths or of no faith at all. In this journey, there were other such coincidences, including finding my grandfather's letters in the first place, and finding myself a regular guest of the hotel he worked on. So what am I to conclude?

I guess I am content to humbly accept the fact that such things happen, that I have benefited greatly from them, and that it is a mystery I will never be able to explain, at least not in this lifetime. I am grateful for these experiences, but not arrogant enough to claim that I know exactly how or why they happen. I will leave that to others more spiritually attuned or deeply grounded in faith than I.

Sample letter from Will to Irene dated June 12. He sent more than 30 of these during his sojourn in Portland.

Strains in Portland—1912

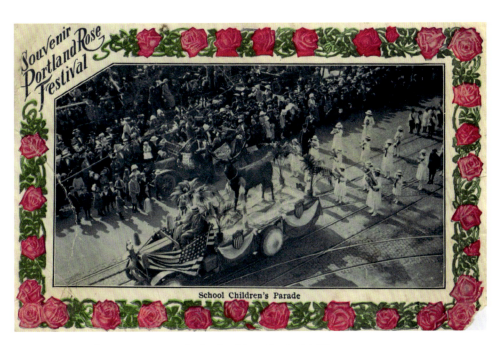

Souvenir postcard commemorating the Portland Rose Festival, 1912.

Message side of the postcard, Will to Walter.

8

The End of the Dream

By early June of 1912, Will was anxious to wrap up his work and head home. With the imminent departure of the Cooks, he had to find a new living space for a few days while he finished his work. On June 9, he wrote to Irene:

> I am settled in my new quarters. It is Sunday morning 7:30 a.m. I came here last night. The first thing I did after I got my grips unpacked was to get into the bath tub. I have a very pleasant room. It is a front room upstairs. The worst trouble here is the noise of street cars and teams and automobiles and motorcycles and motor trucks, and all other manner of traffic which keeps up constantly all night. The horses all seem to have loose shoes that rattle something terrific on the pavement. At John's place the cars only run every 4 minutes so I could get quite a nap between cars.

Will went on to explain that his room at John's was at the back of the house, with the house itself set back from the street, while his new room was in the front, and right over the street. On the other hand, there were compensating factors.

> I have a very good bed here. My bed at John's was an old home-made bed lounge, with about as much spring to it as an ordinary church pew. But I got pretty well used to that and slept pretty good most of the time.

About a week later he reported that:

> My room is all right but the board is pretty slim. We really only get about one meal a day. The rest are make-believe meals.

A couple of weeks later Will wrote:

> I am disappointed tonight I expected to get everything finished today and start home tomorrow. But they have decided to have the fire escape painted again so I have to get a bunch of men and do the work. It will take 2 or 3 days longer so the week is spoiled. I hope to get away by Saturday. Perhaps will spend Sunday in Seattle … I may get mad and get on the train here and go right home.

But Will often found a silver lining in the dark clouds, adding that:

> I found a new place for supper tonight. I saw some homemade light biscuits in a window so I went in and ordered some of them for my supper and they tasted the best of anything I have eaten since I left home. I am going back there for breakfast in the morning.
> Good bye. With love, Will.

Will Lawton returned to Fishtrap in early July of 1912 and life began to return to normal. The *Sprague Advocate* noted in its Friday, July 12, 1912, issue, "J. W. Lawton came home from the coast country Sunday. He has been there about three months." The same edition also noted, "Mr. Gilson sold his ranch to a Mr. Brown last week." Now Gilson would be able to pay his bill at the store and for that piece of farm equipment that Will held a note on. Not only that, he would not be around anymore to complain and sputter about the milk route and everything else.

Irene got some time away when she went to Portland to help her mother move back to Fishtrap. In August Will had the threshers in to begin the harvest. The milk train was seven hours late one day, and it "made it hard on the haulers," and Will hired out his team and one of his hired hands to the telephone crew, who were building a line from Spokane to Portland.

In November Will hired a new man, Charlie Prentice, and he brought someone in to cut wood with a gasoline powered saw; one of his best cows died, and true to his word he reconstructed the milk route and began hauling the new arrangement. But some problems just never go away, and within the month, the Guernsey Creamery man was among the dairymen, trying to start a competing route.

May Lawton Hamilton, Will'S remaining sister, lived in nearby Sprague. Her young adult son and daughter lived there as well. On July 7, 1914 she traveled the 12 miles or so to Fishtrap for a visit with Will and Irene. Seemingly in good health, she suffered a devastating stroke just

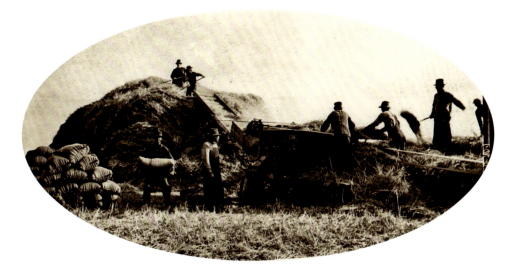

Wheat harvest near Fishtrap, bags of wheat, piles of straw.

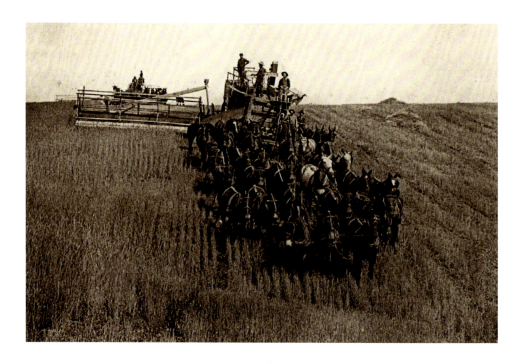

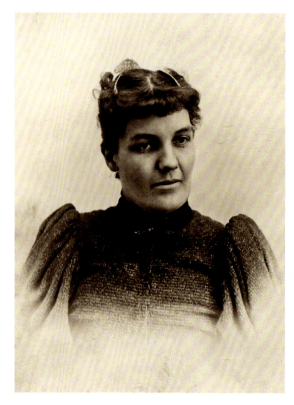

Above: A crew of five and a team of some 30 horses and a couple of mules harvest wheat a few miles west of Fishtrap near Sprague. A second crew follows and a third appears far in the distance.

Left: May (Lawton) Hamilton, another of Will's sisters, who died in 1914 in Will and Irene's home at Fishtrap, age 49. She lived in nearby Sprague and left two children. May was the third sister to die of a stroke and the fourth family member beginning with their father. The women died first and youngest, which is not how we usually think about it. But the deadly condition that triggered the strokes eventually took the lives of the entire generation.

before noon. Soon after her children arrived that afternoon, she passed away at Will and Irene's home, just as Sarah did a few years earlier. She was 49. She was the third of Will's siblings to die from a stroke.

Soon thereafter Will suffered his final stroke and was more or less completely disabled. He died on October 3, 1915 at 52. He followed May by just over a year and lived just two years longer than his father before him. We are not sure exactly how many strokes Will suffered or when they occurred. The first was February 15, 1912, and the last was fatal. In between there were one or two more because we know he was disabled for a period of time before he died. The last few months must have been particularly difficult for him and those around him because they would have known with certainty and dread what was going to happen. Lewis, Flora, Sarah, and May had fulfilled this dark and inevitable destiny, one by one. Other than Will himself, Irene suffered the most.

The writer of the Sprague *Advocate's* story about Will's death noted:

J. Willis Lawton, Postmaster and merchant of Fishtrap, died at his home on Sunday evening, October 3, aged 52 years and 25 days. He has been ill and at the point of his death a number of times since he suffered a stroke of paralysis some two or three years ago. His death while not unexpected has saddened his community for he was truly a good man.

The funeral was held on Wednesday from the Gilman Parlors in Spokane, the party going up from Fishtrap with the body on No. 42 Wednesday evening. A large number of friends and relatives attended the funeral.

J. W. Lawton was born September 7, 1863 at [McKean] Pa., moved to Eau Claire, Wisconsin, when one year old and lived there until 1890 when he located in Spokane and started in business. In 1888 he was married to Miss Irene Bump at Mondovi, Wisconsin. In 190(6) he came to Fishtrap and has been an honored resident of that section since. His wife and four children survive him. The children are: Erma aged 19, Lester 16, Helen 12 and Walter 7.

When 18 years old he united with the M. E. Church and has been a faithful and consistent member since. He was a member of the order of M.W.A. (Modern Woodmen of America) and we understand carried $1,000 insurance.

It was the good fortune of the writer of these lines to meet Mr. Lawton and to become acquainted with him and his estimable family some six years ago and since that time our regard for the man has constantly increased. He was industrious, honest, and above all kindly in spirit toward all including the stranger within his gate. His loss leaves a vacancy that will never be filled for men like him enter our lives but rarely. His death no doubt came as a relief to him as the past few years have been much of a burden, yet the news of his death caused many to feel distinct shock. He led such a life as would cause him to approach the unknown with confidence and complete trust.

This was a remarkable obituary especially since it apparently was written by a reporter or an editor, not the family. The last sentence is open to interpretation. It could mean that since he was a good man in every way, he could only expect eternal life after leaving this one. Or it could mean that he was as courageous in facing death as he was in facing life. It really does not matter; the point is that he was an unusually decent human being whose life was an example to all.

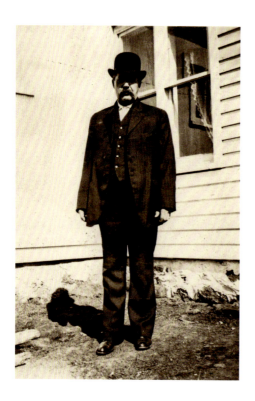

Clockwise from top left:

Photograph of Will, date unknown. Possibly c. 1911 before his first stroke.

Will and Irene after Will's stroke in 1914. Note Will's apparent loss of the use of his right arm.

Will and Irene in 1915 as Will's health declined.

Will's sister, May Lawton Hamilton, was a member of the Christian Science Church in Spokane. To some adherents of the old time Methodist beliefs and practices, this would have smacked of heresy, especially since the Lawtons by then had been Methodists for generations. A family story has it that in desperation, Will sought healing through some sort of Christian Science practice, probably through his sister, May. Although this seems perfectly reasonable given that the cause of stroke was unknown and there was no other treatment at the time, it caused later consternation among a small minority of family members who had migrated rightward theologically, presenting life as a stark choice between a sanctified path of holy righteousness on the one hand, or an eventual perdition of hellfire and brimstone, on the other. As the Methodists modernized with the times, some of the family remained rooted as closely as they could to where founders of Methodism began in the mid-eighteenth century.

When a family lost its father two or three generations ago it was harder in some ways than when it happens today. It happened more often, and although the human loss would have been the same, the economic loss was more difficult. There was no social security, no safety net, and there were not many job opportunities for the women left behind. When Will died, the family's economic security dissipated, magnifying the human loss and causing the family to drift apart.

Barely seven years old when his dad died, Walt later reflected:

> What I remember about it is that Erma came out from one of the bedrooms one morning and told me "Papa died," and I burst into tears, but then it was over and I didn't cry anymore (at the time).

Later on he said that as he was growing up and right up to the time he got married, he still cried for his father. The loss of his father must have been especially difficult for Walter, since he was so very young and occupied that special position as the baby of the family. It was evident from Will's letters that Walter had a special place in his father's heart.

Irene continued to run the place at Fishtrap for a while; she ran the store while Lester, the older son, tried to farm. But Lester was no farmer, and without Will to supplement the store's income with his milk route, contracting and other enterprises, the place just did not work economically. Irene gave up and in 1920, the year farm prices collapsed, she sold the place to Jack Svahn, a local railroader.

Within a year or so, Irene left to be with Helen, who went to teach school in a couple of different places in Montana. Erma, who had married Clifford Dyer, son of one of the original Lake Valley homesteaders, left with her husband and three year old daughter Gwen, for Grandview in the lower Yakima Valley. Lester headed for Spokane where he found work for a few years as a busboy at the downtown Davenport Hotel.

Walt went to the one room school at Fishtrap through the sixth grade in 1919. In the seventh grade, he transferred to the school at Tyler, up the road a few miles and across the Lincoln County line to Spokane County. He graduated from the eighth grade in 1921. After that he set out to work on nearby sheep and cattle ranches. Walt worked cattle for Clarence Dooley on the Figure 3 Ranch and herded sheep for Roy Parsell, both near Sprague. The Parsells gave him a "home away from home" as he put it, and he was friends with their boys who were near his age, one a little older and one just younger. Soon Walt would head into the Idaho mountain wilderness, to herd sheep for four or five months of three of the next four years.

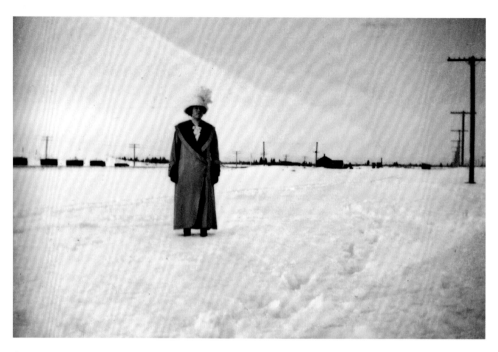

A young woman in winter, possibly Helen c. 1920. The composition of this photograph is at once remarkable and probably unintentional.

Mystery woman of Fishtrap. Identity and date unknown.

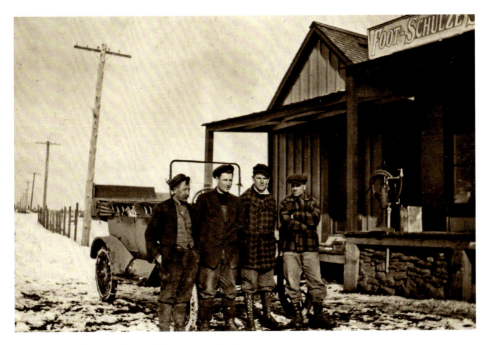

Young men and car in front of the store c. 1916.

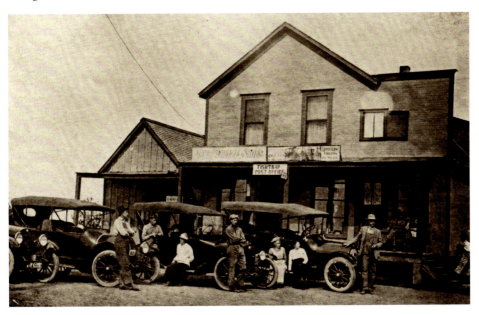

Transition to the automobile age. This photo post card was taken *c.* 1916. Clifford Dyer, whose parents were Lake Valley homesteaders, is the young man standing near the center, fourth from the left. Erma (Lawton) Dyer is seated on a running board one over to the right. She is the young woman with dark skirt and white blouse. Their daughter Gwendolyn was the second and last child born while the family was at Fishtrap. Gwen (Dyer) Hodkinson will celebrate her 100th birthday on July 5, 2017.

Above: Walter, right, and a young friend playing in the sage brush about 1913.

Left: Walter and the family dog Rex, about 1918. Rex became Gwen's dog and years later died suddenly from an apparent heart attack when she returned from a long absence at school. Rex, of advanced age, could not handle the excitement and collapsed on the spot.

Right: Walter and a couple of calves *c.* 1918.

Below: Gwen about one-year-old on "Daisy" with Walter beside in 1918.

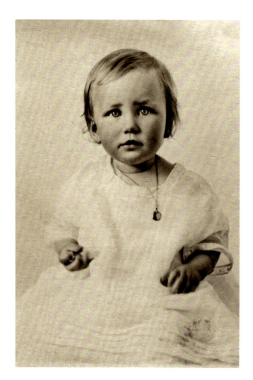 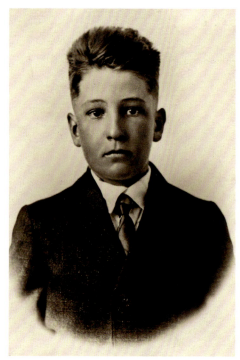

Above left: Gwen at one year and two months, 1918.

Above right: Walter, perhaps about nine years old, 1917.

 Knowing very little about my grandfather when I began, I set out to learn as much as I could about his life. I learned more than I ever imagined I would and, in fact, I probably know more detail about his life than I know of my maternal grandfather's life. My maternal grandfather, Reginald Howard, lived until I was about eighteen and was also a good and decent human being. There is no substitute for actually having known and interacted with someone, but I think I have come as close as possible to knowing Will without having done that. My conclusions about my paternal grandfather and the life he led cannot be put any more eloquently or elegantly than the brief obituary by an unknown, small town newspaper scribe already presented. I cannot improve on it, it says it all.

9

The Exodus

Fishtrap and Lake Valley went on for several years, and as the economics got tougher, people continued to depart and the farms consolidated. A homesteading economy based on 160 acre units was never viable in the dryland west, and this was especially true in the scablands, in spite of the promises made by the railroad and the Government. In reality, people started leaving almost as soon as they arrived. Those who stayed consolidated into bigger farms, and indeed, Will was buying more property as late as 1914, when he added 87 acres bought from Grover Cameron and Frank Smith.

The homesteading cycle in Lake Valley followed a pattern similar to what happened in many other places in the semi-arid west. It began with the open range, which was used by cattlemen and sheep ranchers for feeding their herds and flocks. The open range was followed by division of the land into smaller parcels, by homesteaders for farming to support their families, and for local markets and barter trade. This grew into farm production for larger and more distant markets made accessible by rail lines. Finally, when drought desiccated the land, smaller units were consolidated and the prairie returned to large scale cattle grazing, but this time with barbed wire fencing replacing the open range.

In 1912, Will's letters show that the Fishtrap area was characterized by features of subsistence farming, barter trade, and market production, but over the next two or three decades, the area would slowly return to fenced-in grazing. A renewed period of dry years and the collapse of farm prices in 1920, would hasten the completion of the cycle.

There is still another possibility going beyond fenced grazing: A complete return of the land to its natural state. We will see that this is what happened in much of the Lake Valley area.

The Fishtrap School was consolidated out of existence in 1929, and the post office closed in 1937. One suspects that most people must have left by then, because when two or three are gathered together, politically they will fight the closing of a post office to the death. According to Census Bureau figures, the population of Lincoln County, Washington, reached its height in 1910, when it was 17,539. In 1920 it had declined to 15,141 and by 1930 the population declined to 11,876, a 32 percent loss over 20 years. There are several communities in the county including Sprague. The losses were even more dramatic where homesteading had taken place outside the towns. Even today, the county's population is just a few over 10,000.

The railroad station became a home for a hired hand on a nearby ranch. The only remains of the Fishtrap settlement now are the stone steps of the old store, 100 year old lilac bushes,

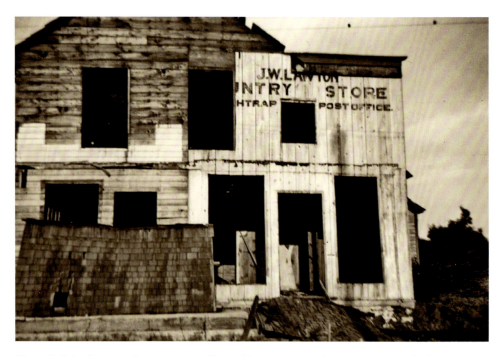

The end of the dream as the store, post office and home are torn down sometime in the late 1930s or early 1940s.

a circle of stones that under laid the silo, the remains of the cellar, and a couple of other rock foundations. Around the clock, the Burlington Northern Santa Fe freight trains rumble by without stopping. Between the trains, the land is quiet with just the sounds of the wind in the grass and the sagebrush, and the chirp of the crickets.

Why did Will pick one of the last pieces of Scabland, when some of the most fertile lands imaginable lay just a few miles to the south in the Palouse? It was all a matter of timing. Will and Irene came to Spokane from Eau Claire and Mondovi in 1890, along with dozens of their neighbors. By then, even the best of the scablands had been taken up. And they spent the next 15 years in Spokane building houses, businesses and lives in the new city. The 80 acres of free land at Fishtrap in 1906 were probably incidental.

It is likely that Will saw a business opportunity to provide services to what appeared to be a thriving community that had a future built around the railroad. And for their own reasons, they apparently wanted to move to the country. Businesses often spring up around new transportation routes, promising reasonable investment returns. From appearances, homesteading seemed to be booming along rail lines in the northwest, including vast reaches of northern Montana. Will and Irene, along with thousands of others, could not have foreseen either the fault lines in the economic assumptions on which homesteading was based, or the looming disaster.

Whither Fishtrap? Fishtrap would appear today as just another exit off Interstate 90. It is exit 254 and is about 25 miles from the western boundary of Spokane. Beyond the Fishtrap name's status as a highway interchange, most local people probably would know something

of Fishtrap Lake. Hardly anyone knows that there once was a small settlement there, which was the center of a farming community. Since the buildings were torn down 70 years or so past, not much has changed. The area is zoned for agriculture except for 40 acres near the interchange, which were re-zoned industrial for a bio-recycling plant. As of this writing, the plant has never materialized.

The Lawton place, as some local people still call it, is about a mile southeast of the interstate at the end of Lawton Road. The road is barely passable as it approaches at a right angle to the railroad tracks and the parallel Jack Brown road. The old store site is immediately south and a short distance east of the tracks. The Lawton place has been part of the same cattle ranch since the 1930s. The Browns were the sole survivors and consolidators in the immediate area.

Much of the remainder of Lake Valley has been bought up by the U.S. Bureau of Land Management. This agency manages some 8,000 acres of publically owned land called the Fishtrap Recreation Area. For the most part, the area has been returned to its natural riparian state by filling drainage ditches and reestablishing wetlands, and is available for hiking, birding, mountain biking, fishing and so on. One of the old farmsteads, the Folsom Place, was preserved and serves as an interpretive site. Chances are that most of the area will remain in public ownership and in its natural state in perpetuity.

Today the area under public management is a beautiful place for outdoor recreation, wildlife observation, and conservation activities. Although easily accessible, it does not seem to be well known and it is not crowded. A nearly complete return of the land to its natural state and available to everyone, is a fitting end to the cycle of human use that began nearly 150 years ago and ended with great loss for many people.

These pieces of concrete and lilac bushes in need of water are all that is left of the old store, post office and home.

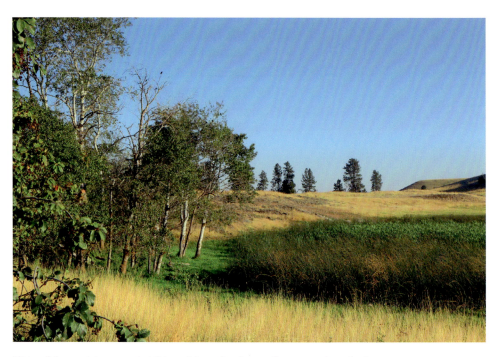

Wet and dry are interspersed at this prairie wetland area adjacent to where the Lawton property once was.

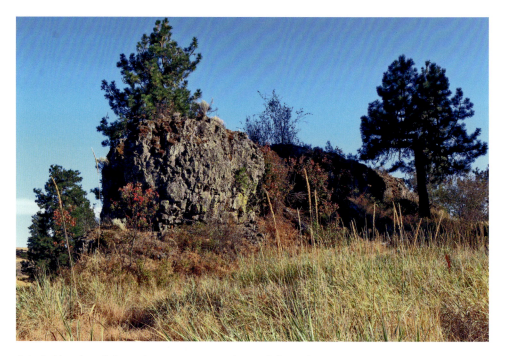

A typical basalt rock formation among many other such formations.

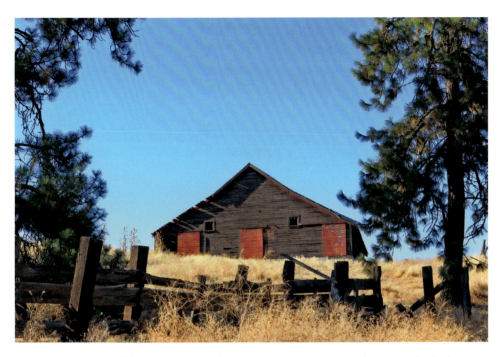

This barn is part of the Folsom interpretive site. The house is long gone but the barn and a shed remain.

The inside of the Folsom place barn. A kaleidoscope of shimmering lights in the sunshine and a sieve of leaks when it rains.

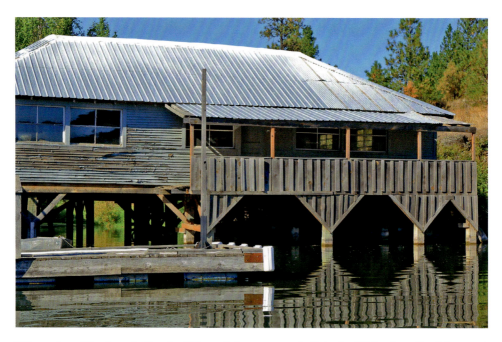

This version of the dance hall at the Fishtrap Lake resort was built in the 1920s after a flood destroyed the old one in the late teens. This building is closed up except for a fish cleaning area at the water level.

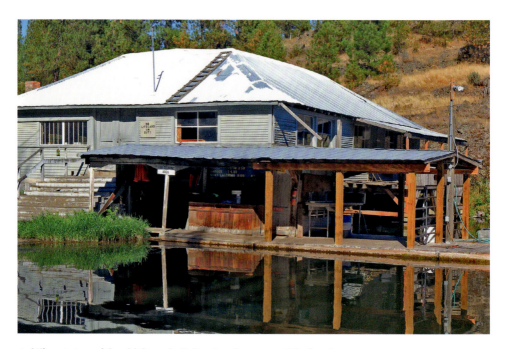

A different view of the old dance hall showing the present fish cleaning area.

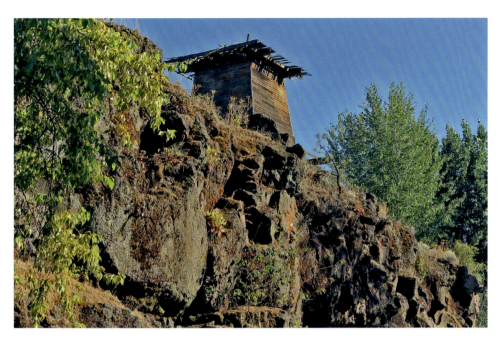

Structure originally built to house the water tank for the Fishtrap Lake Resort on a readymade rock foundation.

Another view of the water tank structure. Note the dust dry moss on the wood siding. It will rejuvenate with the first rain.

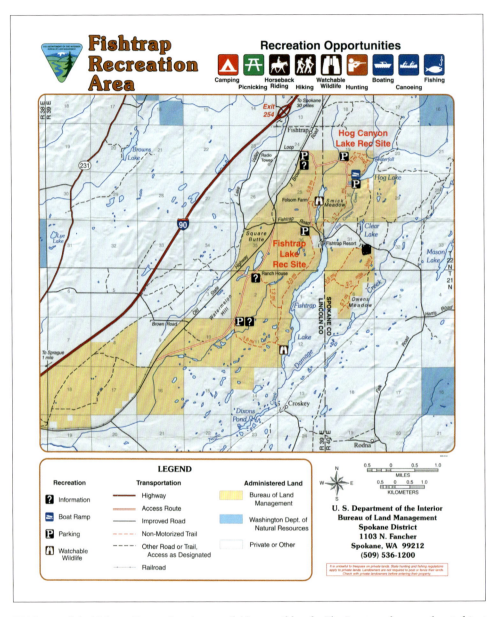

BLM map of the Fishtrap Recreation Area available at trail heads. The Lawton place was located just north of the area in the section containing Exit 254 on Interstate 90.

PART THREE
AN OVINE JOURNEY

10

The Call of the Mountains

Sometime in 1985 I asked my Dad, Walter Lawton, to sit down with me and record his recollections of his sheep herding days. Although he was not a talkative man, he could be a pretty good story teller when he wanted to, and these were the stories I remember most from childhood. I recorded while he talked for a few hours over a couple of different sessions. At the time, I wanted to get his memories on tape without any real plan for what to do with them.

It was evident that Dad wanted to do this. His time in the mountains beginning when he was still fourteen years old was his most memorable adventure. It was not that he loved the mountains; it was quite the opposite. He hated camping, recalling that he had done enough of it to last several lifetimes. But it was a defining time of leaving home and coming of age. As we have seen, his father Will Lawton died when he was seven years old, when he was in the second grade at the one room school at Fishtrap. He went through the sixth grade there, and then finished the eighth grade at Tyler, a few miles away. After that, he went to work on ranches near his home. When he was about 14 years old, he drifted down to a ranch near Ritzville where he launched into his brief three-year sheep-herding career. He started out wanting to learn the shearing trade but ended up as a herder instead.

I carefully put the tapes away and did not do anything with them for several years. Then I saw an excellent documentary called "Sweetgrass, (2009)" which follows the last sheep drive into Montana's Absoroka Beartooth Mountains in 2003. The movie inspired me to get the tapes out, laboriously transcribe them, do historical research for context, and then weave them into the following narrative. The result is the story of Walt's journey into unknown mountains far in the distance, a journey replete with danger, strange people, serious accidents and simple boredom. It is the continuation of Will and Irene's story carried on by their youngest son.

Two thousand sheep, two men and a boy, and a couple of dogs headed out from a ranch in eastern Washington for summer grazing in the Idaho Panhandle's Selway National Forest, a distance of 200 miles, more or less. The boy was fourteen-year-old Walter Lawton, Will Lawton's youngest son, fatherless for seven years and on his own for at least two. He had never seen mountains before, except perhaps from a distance. The men were Bob James, the herder, and Pete Jeauseaud, the camp tender. They left around the first of May in 1923, intending to

A 1933 highway map of southeastern Washington. The black dotted line denotes the approximate route of Walt and his band of sheep through the scablands and the Palouse, then into the Idaho Panhandle.

enter the forest about a month later. By the time they arrived, more than two months had passed, there were considerably fewer than the original number of sheep, and the manpower contingent had diminished to one man and one boy.

They traveled south and east from Ritzville, Washington, to Lewiston, Idaho, thence across Camas Prairie to Kamiah, Idaho, and finally east and up into what once was the Selway National Forest, later part of the Clearwater Forest. The terrain they covered can be divided roughly into three segments.

Their journey with the band of sheep began in the rough terrain of the channeled scablands of eastern Washington. Then Walt and his fellow travelers came out of the scabrock into the fertile rolling hills of the Palouse country, one of the most productive wheat growing areas in the world. Finally, they dropped down into Lewiston, Idaho near the confluence of the Snake and Clearwater Rivers, crossed that threshold, and began the rise through the dry plateaus and foothills of the Bitterroot Mountains and on into the Selway wilderness.

This large group of animals with its small complement of keepers, mostly traversed unpaved county roads and a few sheep trails on the journey. Then, as even yet today in the mountain west, there was a high level of tolerance for herds of cattle and sheep driven to greener pastures.

But, there were exceptions. In a brief encounter, they would soon contend with the only woman they would meet for the next several months.

In any large scale movement of cattle and sheep, there are times when animals stray into fields and pastures when there are gaps or breaks in the fencing or where fences do not exist. Herders usually are quick to get them back with the main herd but with a large number of animals on the move it is not possible to control them as completely as one would like.

Early in the drive, the band of sheep passed by a farm near the dusty settlement of Winona in southeastern Washington, when some of the animals wandered off into a farmer's fields. A girl in her late teens came off the farmhouse porch with a .30 .30 lever action rifle resting in the crook of her arm and confronted the herder at the edge of the road.

"Get them sheep off our property or I'm gonna shoot your dogs," she said.

Bob replied, "You shoot a dog and I'll stick that rifle up your ass."

"May be," she said, "But you won't stick it up my Daddy's ass."

"Well, by damn I will. I'll shove it up his ass too!"

Young Walt, the helper, whose upbringing and sensibilities would not allow him to countenance such talk, at least in mixed company, interjected, "C'mon Bob, you're talking to a girl!"

Pete, the camp tender, sat in the wagon seat, holding his horse's reins and watched with mild amusement. Walt and the dogs began to retrieve the wayward sheep, Bob and the girl stood down, and the herd moved on down the road. Walt said he often thought about the young woman and felt bad about the encounter for a long time.

Bob was the herder and, as such, was at the top of this small hierarchy. Among herders, camp tenders, helpers and dogs, the herder was the "boss," or at least he was supposed to be. The real boss was the owner of the sheep, but in his absence the herder stood in as the responsible person. Bob was an old cowboy in his mid-sixties. He appears to have been on the temperamental side, or maybe just crotchety, and if he were our employee today we might say he had an "attitude" problem.

As Walt told it, "He got mad once and he was gonna quit, and the camp tender called the boss to come up and he talked him into staying. [The boss] came around and told me [the old herder] had been a cowboy in the Texas cattle drives and he used to drive 'em up from Texas to the railhead in Kansas and he was tellin' me that if the old fella quit why he'd take me on [as herder] for the summer."

The camp tender, Pete, was a Frenchman. Pete came to America to farm with relatives when he was 16. Farming did not work out so he took to sheep herding—and ended up mostly tending camp. He had an open wagon, along with a six horse pack string and a saddle horse. The camp tender was responsible for supplies, cooking, and moving camp. Pete could not speak a word of English when he first came over. The real boss, the owner of the sheep, was also French. As Walt noted, when Pete and the boss got together "they'd speak French, really go to town talking French." This was a seed of discord that soon would have consequences.

Walt was the helper and he would not turn fifteen until July 2, two days before they entered the national forest. He got the job through Roy Parsell, a sheep rancher who had begun shearing the animals when he was fifteen. Roy could shear 100 sheep a day in his prime, and spent ten years shearing in Washington, Oregon, Idaho and Montana before settling down to ranching. Walt saw Roy as a father figure and looked to him to learn the shearing trade. But Roy was

not shearing anymore, so he took Walt to the Meyer Ranch on Crab Creek near Ritzville to learn other aspects of the ovine business.

Walt was big for his age and worked like a grown man from that summer on. He was heavily built, just under six feet tall, and had black hair and hazel eyes. Walt's natural tendency to be quiet and reserved, keeping his own counsel was amplified and embedded by his early years in the sheep camps. In modern parlance, Walt's job as helper on the drive to the mountains would be "other duties as assigned." But before long, he would rise in the traveling hierarchy.

The dogs were at the bottom of the scale in this small cadre of workers. Walt described it best.

> You take in Australia and places like that where they have these big bands of sheep, they have their dogs trained different. A few of them, those days, they'd have a good trained dog; a man has got to train his dog from a pup. In America here, most of them, the owner, the fella that owned the sheep, he had dogs and you got a dog, maybe he'd been spoiled, maybe he was a good dog, maybe he wasn't. Your real trained Australian shepherds, border collies, they'll go out there and they'll work around your sheep, they'll be right on guard all the time. But most of the dogs I worked with, they never saw a day's work. The sheep get spread out too much, you whistle and he goes out and heads 'em back. But you get a good trained dog, he'll go out and the dog will be on one side and you'll be on the other, he'll keep track of your sheep.

Some accounts of sheepherding in the old west portray the dogs as superbly trained Australians and border collies that would die to protect the sheep. Sadly, the dogs on this drive had never even met an Australian shepherd and would disgrace themselves before it was over. Walt's portrayal of the modest talents and limited education of the ordinary dog hired for the average sheep drive, may be the more realistic one.

Livestock grazing on public land is a time-honored tradition in the west. Cattle grazing after the Civil War, of course, gave rise to the brief era of the cowboy and its overblown mythology. Basically, grazing on public lands was about free livestock feed, which helped provide a way for people to get into the cattle or sheep business with a smaller capital investment than would otherwise be necessary.

In the beginning, uncontrolled livestock grazing led to the creation of cattle empires and the accumulation of fortunes. It also led to competition and conflict as sheep began to crowd out cattle, and then homesteaders fenced out both. As Walt told it,

> Years ago … in western country there used to be some real old sheep wars. The cattlemen came in first, they got all this free range, that's what made these big rich cattle outfits, all this free range, then the sheep men began to move in and then there was a battle because cattle on an open range, they don't mix very well. Of course, it wasn't as bad as what they claimed it was. [An old sheep man was] telling about up there in Montana when he was just a young man, a bunch of cowboys came around harassing the sheep herder, he didn't do anything but they finally shot his dog, so he up and shot and killed a bull. Many years ago there was a lot of bitterness, same way when the homesteaders began coming in, that's what put a lot of the cattlemen, sheep men out of business …

Because of the conflicts, President Theodore Roosevelt appointed a commission to investigate the practice of grazing on public lands. From this investigation came a policy of charging for grazing permits, which had to be renewed every year, and which applied to specific allotments of grazing territory for each permit. This was the end of free grazing on public lands, although the allotment charges were still inexpensive. The significance of the change was that specific allotments ended the sometimes violent competition. The grazing system was further defined by the Taylor Grazing Act of 1934. While grazing public lands still exists today, it is a shadow of what it was 100 years ago.

By 1923, the sheep industry on the Columbia Plateau in the Northwest had passed its peak. Nevertheless, it was still a major industry and there were hundreds of thousands of sheep in central and eastern Washington and Oregon. For summer grazing they were driven in all directions by herders and dogs into the surrounding mountain ranges to their allotments. And they were shipped by rail to graze on the short grass prairies of North Central Montana. In the fall, they were driven and shipped back to their sheltered winter ranges on the Columbia Plateau. As Walt noted:

> Thousands of sheep used to be shipped on the trains from Washington up here in Montana for the summer. They'd load 'em up around Prosser, Yakima, all around through there, ship 'em up, most of 'em come around Browning, they'd unload around Browning, pasture out there … Some of 'em went up in the mountains later in the summer. They'd get up there and wear out the grass and then drift up toward the mountains. One thing up there, there was a lot of grizzly bear up there.

Young Walter Lawton in sheep camp *c.* 1922, age 13 or 14.

Form 621. (Revised July, 1916.)																	
Name Edmond Meyer								Selway National Forest.									
Address Ritzville Wash								Recognition based on _____ (Prior use—Grant—Purchase.)									
YEAR	CLASS	DATE OF APPLI- CATION	NO. APPLIED FOR		NO. APPROVED FOR		NO. TO LAMB.	NO. OF REG.	DIS- TRICT NO.	PRO- TEC- TIVE LIMIT	GRAZING PERIOD		AMOUNT OF FEE	F. A. CERTIFICATE			PERMIT ISSUED
			Cattle. Sheep.	Horses. Goats.	Cattle. Sheep.	Horses. Goats.					From—	To—		No.	Date.	Amount	
1925	C	2-14	1300		1300						7-1	9-30	87 75	237	4-30	87 75	5-12
1926	C	2-10	1300		1300						6-1	9-30	104 00	460	4-23	104 00	4-27
1927	C	2-7	1300		1300						6-1	9-30	104 00	564	4-1	104 00	4-13
1928	C	2-3	2000		2000						6-16	9-30	198 75	681	4-23	198 75	5-5
1929	C	2-13	1900		1900						6-16	9-30	230 37	802	5-3	230 37	5-6

Remarks:

Grazing allotment record for the Edmond Meyer ranch in the Selway National Forest (now Clearwater) 1925 through 1929. *Courtesy of the U.S. Forest Service, Nez Perce National Forest, Grangeville, Idaho*

Form 621. (Revised July, 1916.)																	
Name Camille Meyer								Selway National Forest.									
Address Ritzville, Wash								Recognition based on _____ (Prior use—Grant—Purchase.)									
YEAR	CLASS	DATE OF APPLI- CATION	NO. APPLIED FOR		NO. APPROVED FOR		NO. TO LAMB.	NO. OF REG.	DIS- TRICT NO.	PRO- TEC- TIVE LIMIT	GRAZING PERIOD		AMOUNT OF FEE	F. A. CERTIFICATE			PERMIT ISSUED
			Cattle. Sheep.	Horses. Goats.	Cattle. Sheep.	Horses. Goats.					From—	To—		No.	Date.	Amount	
1925	C	2-14	1800		1800				Mf		7-1	9-30	121 50	239	5-4	121 50	5-12
														431	3-8	104 00	
1926	C	2-4	2000		2000				"		6-1	9-30	160 00	445	3-31	56 00	4-3

Remarks:

Another grazing allotment for the Meyer ranch. These records account for about 2600 sheep in each of the years 1925 and 1926. For Walt's venture into the grazing area in 1923 they were allowed about 2000. *Courtesy of the U.S. Forest Service, Nez Perce Forest, Grangeville, Idaho*

Besides the free or nearly free feed in the mountains, herders scrounged more along the way and on the way back. Walt explained:

> Those days the summer fallow was plowed by horses. So long as there was a lot of volunteer grain, especially if they had a good wet spring, there was a lot of volunteer grain on the ground that wasn't plowed for summer fallow yet, they liked to have the sheep come in and eat it down, then it was a lot easier to plow under. We took in this free feed everywhere we could.

And on the way back:

> We were supposed to hit stubble field coming down through the wheat country, pea country; sheep in those days coming out of the mountains, they'd feed on wheat stubble, pea stubble, as long as they could, 'cause it was good feed, ground wouldn't be wet enough that they'd have grass at home much.

If you could look down on a band of 2,000 bunched up sheep from above, its shape might resemble an amoeba, a moving mass in the middle with a shape shifting perimeter oozing out here, then there. The texture would be 2,000 wooly bumps like some kind of lumpy fabric. And the sound would be a constant, unremitting blatting that one might think would drive a normal person to eventual insanity.

So Walt's outfit moved along to the southeast, kicking up a cloud of dust—through Uniontown and Colton in Washington, and over the bluff and down into the Clearwater River bottom to Lewiston, Idaho. They headed up the main street of town on a Sunday morning as the church hymns wafted with the breeze, mingling with the blatting of the sheep and the barking of the dogs. Past Lewiston, they followed the Clearwater for a while and then turned to go through Lapwai, on to Camas Prairie, through Reubens and Mohler, and then down to Kamiah, where they began the ascent into the mountain grazing areas.

Walt picked up a gun along the way and carried it from then on:

> An old fella, one time around noon, I was stopped along the road and he came out and wanted to know if I wanted to buy a gun, and being kid like, I bought the gun—I had to have that gun, I carried it all summer. Carried it every time I herded sheep after that, for a long time. It shot a .32 .20 rifle shell in a Colt .45 frame.

Walt seemed to attribute the desire for the gun to his adolescent immaturity. There could be another less conscious explanation. An old man appeared from nowhere with the gun. A gun is a weapon first and foremost. But it can also serve as a psychological protector, confidence builder, and "great equalizer," to defend against and ward off unknown threats lurking in an opaque wilderness ahead. In other words, it likely served as an amulet, totem or talisman, a protective symbol on his journey. Whether justified or not, this is a big part of the mystique of guns. He would actually use it only a couple of times. And the gun was no help in the calamity about to befall them.

Near Reubens, Idaho they had to cross a Camas Prairie Railroad track. This was a local line that served farmers in the Camas Prairie area. This particular track carried one train each day.

The train would go up out of town at night and then come back in the morning carrying milk into Lewiston. The sheep were strung out, crossing the track at an angle. No one expected a train to come around a bend just at the time they were crossing. When they heard a distant rumble telegraphed down the steel rails, they looked up and saw the tell-tale plume of black smoke and white steam moving swiftly toward them and the sheep on the tracks. With the shriek of the steam whistle in their ears, they barely had time to begin moving the animals off the road bed before the train was upon them. The engineer had a few seconds before the looming carnage to remember that it was spring, and that the wool of the sheep would not yet be grown out. A collision in the fall would be more serious (for the train) because the long wool would plug up the drive wheels and rods, and it would take a major effort to remove it.

Two hundred fifty tons of steel on a downgrade "plowed right into 'em," creating a ghastly mess of hair, hide, blood and bones. The engineer had applied the brakes and the train slowly ground to a screeching stop in a shower of sparks. After they recovered from momentary shock, herder, helper and camp tender began to cut the throats of the badly injured and get them off the ties. The train crew began to clear the tracks of the mess, and to examine the engine wheels and rods to make sure they could get underway again. After depleting their initial store of curses, the animal tenders and train crew worked without a lot of talk or recrimination. What else was there to say? It had happened before and would happen again.

Walt said that:

> There was quite a bunch of them, 30—35 sheep crippled and killed. There was no way to salvage them. The worst of it was there were so many lambs left without mothers.

Asked what they did with them, he replied:

> Well, took them along, they were just orphans. Lost a lot of 'em because some were crippled and died along the road.

They lay over for a few days, giving the less seriously injured animals time to begin to heal up before they moved on. Their troubles didn't seem to let up. From Reubens they went on toward Mohler. Walt continued his story:

> It turned out hot that morning, early, real hot, we had stopped, trailing along county road; there was woven wire on each side so we just let the sheep stop there till it got cooler. We were stopped there when a black cloud came up, and there was a bean field just below us, there was just two leaves of beans showing, nice rows of beans, hailstorm came up and it came down there, and when it got through you couldn't even tell there had ever been a bean in there. Looked like it had been plowed. I had to go up to the head of the sheep, tail end actually, because the storm was coming where it was driving them back the way they came, so I got out there to hold 'em back, standing there in that hail, looked across country about two miles, and I saw a fellow standing out in the sunshine. It was just a small cloud that came through. That's very common in that country—they have a lot of hail there.
>
> We went on into this little place called Mohler, there was a church there and a school and a store and a few houses. Around the church and the store there was a flat open space, weeds and

stuff there, they was glad for the sheep to come in there and eat it up. We sat there and let them eat for a while, and camp tender had gone in for supplies, pick up some supplies, and he came out and said, "Let's get 'em on the road Bob." And Bob said "You want 'em on the road, put 'em on the road yourself!" That's when he quit. Camp tender, the reason he was trying to be the boss there, he was a Frenchman and the boss (owner) was a Frenchman, they'd known each other for years, so that's why he felt like he had an in there.

So Bob stalked off and was never seen again. That's how Walt became the herder. But he still wasn't the "boss." As Walt explained:

Well, ordinarily if you had an experienced sheep herder, he's the boss. He tells the camp tender what to do. But since I was just a green kid, why he ran the thing, he told me what to do.

 Nevertheless, it was a win—win situation for Walt and Pete. Walt's pay was increased to $50 a month, he was nominally moved up to management, and Pete got to be the real boss. Sadly, though, it was all at Bob's expense. Such are the ways of the world of hierarchy and politics. Walt rounded up another kid in Mohler to help them get up to the grazing allotments and they got on the road once more.

The star-crossed outfit headed for Kamiah (pronounced Kam-ee-eye) and up an eleven or twelve mile grade toward the forest boundary. Somewhere along here is where they set off a rock slide that closed the road for three days. Walt explained:

Going up this county road on Haystack Mountain, it was a narrow winding road … [the road] dug out of the side of this mountain, up above the road was a lot of shale rock.… The sheep got up there—I didn't know anything, first time I'd ever trailed sheep—got up there and I sent the dogs after them and they came down and had that old road piled full of shale rock. The county road boss came by and it took a crew about three days to clean up the road after we'd gone through.

Finally, without further incident, they reached the forest boundary, the final threshold. They passed a ranger station on the Fourth of July and a ranger "counted them in" that night, just two days after Walt's fifteenth birthday. The rangers gave them a map and marked a place to camp. They made it into their allotted range the next day. They were late by a month and a few days.

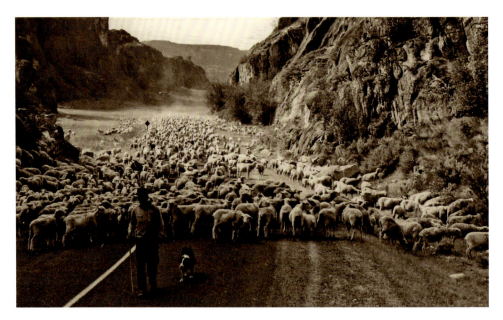

A band of sheep belonging to Joe Hodgin trailing through Eagle Rock in the upper Grand Coulee on their way to summer range near Republic, Washington. Rivers of sheep on their way to or from the mountains like this, were a common sight during the 1920s, 30s and 40s in eastern Washington. This is what Walt's trail drive looked like, through similar country, nearby. *Photo by H. W. Fuller provided by Grant County Historical Society, Ephrata, Washington*

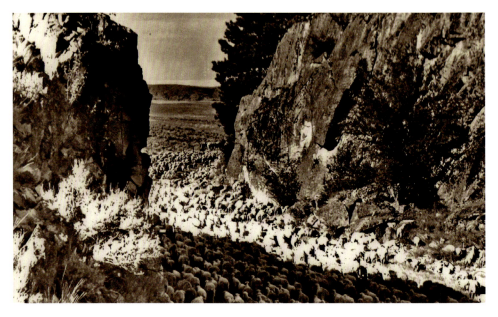

Another eastern Washington view of sheep on their way to summer range in the mountains. *Photo by H. W. Fuller provided by Grant County Historical Society, Ephrata, Washington*

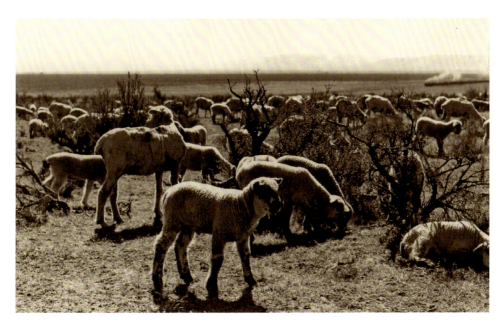

Ewes and lambs stopping to browse on their way to summer mountain grazing range. Ewes are recently shorn, lambs will be sold in the fall or will wait until the next spring for shearing. Note the train, upper right. It was always hazardous crossing the tracks with a band of sheep. *Photographer unknown, photo courtesy of the Grant County Historical Society, Ephrata, Washington*

Hodgin and McDonald shipping lambs to Chicago market from range in Colville Forest Reserve at Republic Washington. *Photo by Howard C. Robinson, courtesy of Grant County Historical Society, Ephrata, Washington*

11

Alone in the Wilderness

The worst forest fires in the history of the United States took place in 1910, thirteen years before Walt and his band of sheep arrived on the scene. The summer of 1910 had been hot and dry and fires were smoldering all over the West. They were ignited by lightning, trains, arsonists and hoboes. Fuel had been accumulating for decades—slash from logging, mine construction, and homestead clearing; and duff on the forest floor accumulated, in part, from a policy of vigorous fire suppression by the Forest Service. The regular U.S. Army was mobilized that summer to fight the fires.

On August 20, 1910 a cold front accompanied by high winds blew in from the west. Dozens of smoldering fires exploded into a roaring holocaust that killed 78 firefighters, at least that many civilians and more, and burned over three million acres in the Idaho Panhandle and Western Montana. Whole towns were wiped out and the smoke darkened the sky as far away as New England. One of the three main centers of this fire was the Clearwater National Forest.

The grazing allotments for Walt's band of sheep were located in the burned out area from the 1910 fires. They were situated between the headwaters of Dead Man Creek and Fish Creek, and under mountain peaks called Frenchman Butte and Middle Butte. The area was about twelve miles from the forest boundary as the crow flies, a little further by Forest Service road. This general area had also been traversed by Chief Joseph and his band of Nez Perce in their flight to escape the U.S. Cavalry in 1877, and by Lewis and Clark on their journey west in 1805.

Walt described his first exposure to the mountains.

> We got up there and I didn't know anything about mountains. I had been raised out in the scab rock wheat country there around Lincoln and Adams County. Camp tender asked what I thought of those mountains … and I told him they look awful rough to me. And he said that's the way mountains were and when you get up on top of a mountain you can find a level place and see one series of mountains after another.
>
> We just got into camp, we'd been on the trail so long (Pete) had to go back for grub right away and take the boy (they just hired from Mohler) back to let him go home. He had helped me the rest of the way up. While (Pete) was gone I decided to slaughter some mutton. In camp one evening I caught a nice fat one and killed it. Didn't think about hanging it up until it was (already) dead. The only thing that was there was a small kind of tree that had been burned black. We were in this basin there, where three big fires had come together in 1910. Though most of the timber was

dead, there was some live timber amongst the dead. There was this old black snag up there; tried to hang the mutton up there. It was about as black (as the tree) when I got it skinned, so I drug it along the (road) for a mile or two and then when he got back … we cut the mutton up, rubbed salt on it to hang it out and dry, and it was like a bunch of bones rattling around in the sack.

When Pete went into town for grub, it did not include meat. Why spend cash on meat when you have all you can use right there on the hoof? So they killed a sheep when they needed to replenish their meat supply. They wasted nothing as Walt's narrative shows. His descriptions of the cooking and eating processes, as the story continues, may seem primitive to some modern readers, but that is how they did it then and still do in some parts of the world today.

So they settled into the routine of camp life. Inventory shrinkage in the sheep department was about to worsen.

The permit allowed us to be in the first of June and we had to be out by the last day of August, first day of September. While up there they… on the forest reserves you can't bed the sheep down more than three nights in one place, and you are not supposed to bed them down that many times if the ground is too badly pulverized from the fire, which a lot of it was, just ash.

So you would just roll up your bed each morning, put it on a stump, and you followed your sheep around till they stopped that night. There was no place for them to go; there was just food in every direction, water in every little draw, never had to worry about water, and you moved your bed up to where they bedded down for the night and you slept there, just made a circle around the range there. If I had known more about what I was doing, I would have planned about how to go around the allotments so you didn't have to backtrack. I didn't know what I was doing, and the camp tender he knew, but he didn't seem to tell me much about it. Oh, it wasn't bad, I didn't have to backtrack much anyway.

The sheep would start out early in the morning as daylight was breaking. The hungrier they were, the faster they would move out, and Walt often had to move quickly to hold them back and to keep them together as much as he could. When they began to fill up they would settle down to eat at a leisurely pace, keeping together more easily. In the heat of the day they would bunch up, lie down, chew their cud and sleep. The cool of the evening got them moving again, and they began to fill up once more. Although these ovine critters like the shorter grasses, Walt observed that "sheep do better on brush, weeds, and stuff like that than they do on grass." He also noted that the North Central Montana plains with their short bunch grass, were a destination for sheep from the drier Columbia Plateau in Washington, and that Montana sheep men did not have to go to the mountains when the grass was good all summer.

One of the fringe benefits of sheep herding was having your own cook and housekeeper. As Walt described the role of the camp tender,

He moved camp for me, he did the cooking. When he butchered for mutton, he saved the lungs, he ate them, called that the "white liver." I always liked the regular liver. I always loved liver and hotcakes for breakfast. Liver didn't last very long, anyway. Then he'd boil the head there, I'd come in at noon and he'd have a pot with this sheep head laying in there, eyes staring you up in the

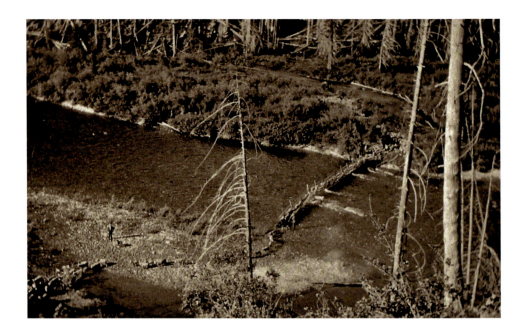

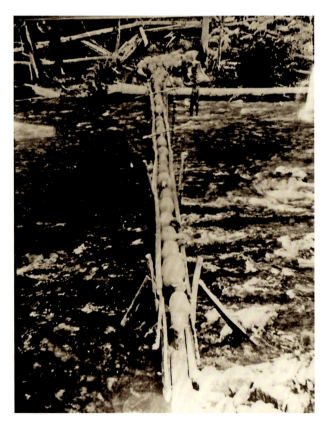

Above: Kelly Creek Sheep Bridge in the mid-1920s, Louis Hartig photo courtesy of the U.S. Forest Service, Cindy Schacher, Central Zone Archeologist, Nez Perce-Clearwater National Forests. This was near the Clearwater area of Idaho where Walt took his summer band of 2,000 sheep.

Left: Cayuse Creek Sheep Bridge in the mid-1920s, John Gaffney Collection photo courtesy of the U.S. Forest Service, Cindy Schacher, Central Zone Archeologist, Nez Perce-Clearwater National Forests. This photo was also in the general area of Walt's summer range.

face, then when he was ready to eat he'd pull the jaws apart, dig out the brains and eat 'em, peel the tongue and eat it, he ate the heart, he ate everything but the blat almost. Never could stand tongue or brains after that; I didn't eat 'em before, as far as that goes.

One thing he did do, he used to make light bread, he carried one of those oval roasters, he'd make light bread, back in those days you had dry yeast, "Magic Yeast," he had yeast along with flour for making bread, we'd have fresh leg of mutton after the bread was baked. The way he'd bake it, he'd dig a hole, burn limbs and stuff over that, and get the hole full of red hot coals, then he'd pull that out and he'd stick his bread down there then cover it with coals and bake the bread. Take about an hour to bake down there. Then when he'd get the bread out, he'd put a leg of mutton in there and cook it. He liked garlic; he'd sit there with his knife and poke holes in that, he'd have about 15 or 20 cloves of garlic in every leg of mutton.

Mutton has a reputation for having a gamey taste and tough texture that many people do not like. That's why you cannot buy it in a store—there is no market for it. Lamb, on the other hand, is considered by many to be among the finest choices of meat. You will not find a fine French restaurant without "rack of lamb" on the menu. When Walt speaks of "mutton" it isn't as bad as it sounds. He isn't talking about meat from a tough old sheep, he is talking about something close to what we call lamb today.

In the fall, when you sold your lambs, there were always bum lambs, late lambs that were born too late, that never made market, you'd save those, that's what you ate. Actually, what they were called was "breakers." It was called "lamb" if you could break its leg (in the butchering process). If you can't break its leg when they're skinned out, if that leg would break in a certain way, it was called a "breaker," that was just between a lamb and a mutton. It was just as good as eating lamb as far as that goes.

Most stories about herding sheep make reference to legends of sheep herders going crazy while herding in the wilderness. The proximate cause usually is given as loneliness or the incessant blatting of the sheep. Walt had a different take on it.

They always talk about how the sheep herder went crazy from being up there listening to the sheep. I don't think that was the reason they went crazy. The reason they went crazy, if they did, was because back in those days, earlier days when they furnished the bedding, never heard of such a thing as a sleeping bag. The company would furnish a bedroll for you, and they bought these cheap quilts, they were perfectly square, they were always too short ... either your shoulders were out or your feet were out. If there was anything that made a sheep herder crazy, it was trying to figure out the long way of a square quilt.

Square quilts weren't the only hazard of sheep herding. There were many others as well, but alcohol didn't seem to be among them, in the camps anyway. In town was a different matter.

When (sheep herders) get to town, they are the hardest drinking guys there are. Well, they used to be, they don't have your sheep herders now like they used to. A lot of the old sheep herders they'd

go out in the spring after lambing, they'd go to the mountains, be gone about six, eight months till they got back to the ranch. They'd never draw any money except for what clothes they had to have, or tobacco, then they'd draw the money, go into town, get drunk … they'd be drunk for a couple of weeks, the money gone, come back, stay all winter, then in the spring, back up in the mountains—same old thing, they'd stay right with the sheep and take care of them.

First time I ever tasted whiskey was when I worked for Edmond Meyer. Back in the prohibition days, he always had whiskey around, moonshine, I'd never tasted it, I'd never even seen any before. Went down there with Roy Parsell during shearing time, just before dinner, why he took us into the bedroom, I didn't know what we was going in there for, but he had a jug in there, gave Roy a drink, then handed it to me. I didn't know what it was, I just took a drink and boy! It took the top of my head off. It was about the worst tasting stuff I ever got a hold of. Every time he came up (to the mountains) he'd bring a bottle along. As a rule, they don't allow much liquor up there, those guys (sheep herders) when they get drunk, they just get dead drunk.

Walt and a young friend, probably one of the Parsell boys, in sheep camp, *c.* 1923.

12

Night Terrors

Walt experienced the frights natural to a green, fifteen-year-old kid (or anyone else) alone in the mountains with just the sheep and the dogs, laying a bedroll out on the ground every night, often as not without a tent, in the intense blackness that envelops the mountains on a moonless or cloudy night. The totality of mountain darkness creeping in as the daylight fades away, is palpable. And things that go bump in the night might register higher on the terror scale than when you are enclosed in four walls and safe in your own bed. The darkness is somewhat mitigated during midsummer, since it doesn't get completely dark until after 10 p.m. and it begins to lighten up at 4:30 or 5:00 in the morning. And familiarity breeds acceptance, which helped Walt to adapt quickly.

When sheep would move into an area, the deer would move out. Smaller animals would stay around and larger predators might move in. For Walt, some scares were imaginary, some were real though harmless, and some were deadly. He told of a couple of scares on a different trip, but still in the Panhandle area. This time he had a tent, and the camp tender would bring food up to him every day where the tent was pitched.

> In those days rolled oats and stuff like that came in cloth bags, 10 pound cloth bags, 24 pound sacks of flour in cloth bags, everything was in cloth bags, you never had any paper like you have now. So he'd bring stuff up there in the cloth bags, and when there was an empty bag, I'd stuff the small ones into the bigger one and hang it on the tent pole, tent peg, out there in front of the tent. When he'd come up, he'd pick 'em up and take them back. When I came in at night I'd just toss my hat on the tent peg. I don't know what caused me … but one night I woke up and my eyes just focused out there, and the hat, the peaked crown hat on the tent peg, and this sack, looked exactly like a cougar there, his head there, and standing there with one paw up, like to scared me to death when I saw that. Finally the moon moved enough so that I could figure out what it was.
>
> Then another night I was sound asleep, when all of a sudden something came tearing in the tent and landed in the middle of me, and right after that a dog landed on me and he was scraping and scratching up the tent wall. I … struck a match and the little dog had chased a big fat packrat in there that landed in the middle of me. You can sure get some real scares out there like that.

When asked how long it took to get back to sleep, Walt replied:

> Oh, didn't take long, those days, 10 minutes and you were back to sleep again; used to those things.

Coyotes and bears, and now wolves, are the bane of sheep and cattle ranching in the Mountain West. If it were not for forest fires, bears killing livestock and snacking on an occasional tourist, and transplanted wolves slashing cows and sheep to gruesome death, half the newspapers in the region would have to close up shop for the summer because there would be no news.

On their trip into the Selway, Walt and Pete didn't have any encounters with wolves or coyotes, but bears were another matter, and were a bigger cause of inventory loss than the train wreck. And the myth of the noble dog was shattered.

> Then along towards the fall, we got in this place right down under what they called Middle Butte, coming back up towards the trail and getting ready to move out. Got up one morning and it was so foggy and rainy, sheep didn't go out right away. During the night I heard them running and fussing down there. Camp tender told me, I'd always asked him all the time, I said, "How will I know if a bear gets in the sheep?" "Well, the dogs will let you know." Well, the dogs weren't making any noise, but the sheep were so restless I finally fired a shot out across there and they quieted down. Then when I came back from breakfast that morning, the fog raised, and I found that a bear had been in there and killed 21—22 sheep. Didn't kill 'em all, but between what he killed and what he crippled, it was a total loss. Then we moved on up, started moving along the trail trying to get away from him, and he kept following us, and a few nights after that he got in again and killed about 20 more, we lost about 20 more.
>
> Dogs never barked once until I shot and scared the bear away, then they barked a lot. (We) had an old .30 .06 or .30 .30, I forgot which it was, the thing only fired once in a while, you could never depend on it firing. And this Frenchman out there trying to … said the bear came along towards morning, and raised up to shoot it, the gun didn't fire, just clicked, and of course the bear turned around and ran, never did get to shoot it.

Once again they had to cut the throats of the maimed and count up their losses. They kept moving up the trail on their way out of the mountains when the bear hit them again, apparently for the pure enjoyment of it, since he couldn't possibly eat more than one sheep at a time.

> We moved out further and along the trail, and I was sleeping one night bedded down out about a half a mile from camp, sleeping out in kind of a clearing and lying out there with my bedroll. You always had a canvas tarp to wrap your bed in to keep it from getting wet. Something woke me up in the middle of the night, I don't know why, but when I woke up my eyes focused on this big old black thing lumbering up toward me. Of course I was scared spitless; if it's possible for a person's hair to stand on end, mine was standing on end. I got up and put my shoes on, and by that time the bear saw me. He took a little whiff but the wind was blowing the wrong way. As soon as I got up, why he snorted and turned and went down the hill, and I shot out across there, and the dogs began to bark out in the middle of the sheep. They were scared; *they smelled the bear before he was coming up there, and they hid out in (the midst of) the sheep.*

In this case, to err is canine, and to forgive is difficult. But if I were the dogs' defense attorney, I guess I would invoke the "there are no bad dogs, just bad owners" legal doctrine. Moreover,

karma kicked in, and the owners paid the price in lost sheep for providing untrained dogs. On another occasion, a different trip, it was just about as bad, besides putting Walt in jeopardy.

> … I was out there alone with the sheep, sitting there one day, nice warm sunshiny day, I heard a little commotion. I looked around and a little bear cub came by, he looked up and saw me and went right up a tree. I knew there was a sow there, not too far away, so I quietly got the dogs together and got out of there as quick as I could, because I didn't want any argument with a mother bear and her cub.
>
> Then several days after that, I was going down a ridge where it had been homesteaded years before but had been abandoned, open clearing with just a few little Jack Pines coming up here and there, tallest one was about eight feet. We had a shepherd, female shepherd dog, and I had a little black Australian Shepherd dog, two of 'em. This female, she was hard of hearing, she'd been spoiled, she'd been let run after chipmunks and stuff, she was always ranging around there. I heard a dog barking and pretty soon she come up out of there just streaking, and right behind her was this big old black mother bear. While I was standing there, the stupid dog came running up to me, and of course the bear didn't stop, the dog ran by, and when the bear discovered me she stopped and we stared at each other for a while. (Then) the bear turned around and ran back down the canyon and the stupid dog, instead of staying, took off and ran down there and chased the bear, then they seesawed back and forth there three or four times. I was getting awful sick of that bear when I finally got the dog to stay, then the bear went on down the canyon and circled back up and came up on top of the ridge and sat up on its haunches and looked at me for a while.
>
> A black bear when they sit up, right in the chest there is a white spot, and they say if you can hit 'em there, why that's a very vulnerable place to shoot a bear. You want to be careful when you are shootin' a bear, you don't hit 'em in the head because it is like shootin' against an iron rail. Shoot a bear, you want to hit 'em in the back of the head behind the ear, or in the heart or lungs or something. To hit 'em in the brain, you can't very often get the bullet to penetrate the skull.

About the same time they were dealing with the sheep-killing bear, they were moving camp one morning when a big bull elk with a rack of horns popped out of the brush in front of them. They didn't kill it because their armory was so pitiful they didn't have anything to kill it with. A few years later Walt was swapping stories with the herder that took over the band the following year. A bear, presumably the same one, got into the sheep and followed them until they finally poisoned it. They saw the same bull elk and shot it. "He said they were sure sorry they did, because they couldn't begin to use the meat."

Toward the end of August the days were growing noticeably shorter, the nights turned colder; and yellows and reds began to appear, first in the shrubs and low growing plants, then in the aspens. It was nearing the time when they would head down the mountain slopes, across the prairie, and back to the ranch in the scablands.

With the depredations of the bear and the railroad locomotive, along with other scattered losses and sacrifices for food, they lost around 100 sheep, maybe a few more. Out of a summer band of 1,000 ewes and 1,000 lambs, that amounts to a five or six percent loss. It probably was not that bad considering all the potential hazards.

How do you account for a band of 2,000 sheep? Take inventory every so often? Not likely. Bar coding was still a half century away. Besides, the sheep would spread out so that the herder often could not see them all at once. In a band of that size, there were always a few with different markings, all black or a spot or patch of black or brown. They would also put bells on a few of the sheep. By counting and keeping track of the bells and the "markers" as proxies for the entire band, they could have some assurance that most, if not all, were present and accounted for. The term "bellwether," meaning something or someone out in front of the rest, comes from this practice. A wether is to sheep as a steer is to cattle or a gelding to horses.

Band of sheep in mountain summer range. *Photographer unknown, photo courtesy of Grant County Historical Society, Ephrata, Washington*

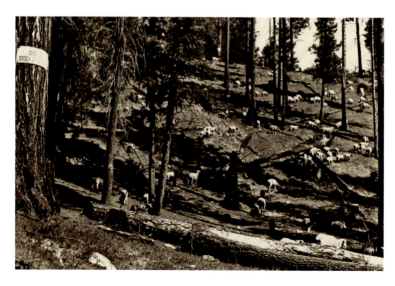

Sheep grazing in Forest Service allotment. *Photographer unknown, photo courtesy of Grant County Historical Society, Ephrata, Washington*

13

The Return

Not only was Walt alone much of that summer, the stillness of the wilderness broken only by rushing streams, the wind in the pines and blatting sheep, he didn't get any mail, though he sent frequent letters to his mother and sisters. When Pete went to the nearest settlements to get supplies, he always stopped at the post office to pick up general delivery mail, where families were instructed to send things.

> All the while I'd been up there, writing to the folks all the time. Every time the camp tender went to town I sent letters to the folks, and I kept asking why I didn't get a letter from them, why I didn't hear from them. One day we were in camp and the forest ranger or one of his assistants came around. Coming to find out, he was a nephew of Roy Parsell who lived around Sprague. This nephew of his, he brought a letter along. He'd gotten it from Erma (Walt's sister) I guess it was; she said she didn't understand why I said I wasn't getting the mail, because they'd kept writing. So I found out they hadn't forgotten me anyway. Then as I was coming out, I came by a little post office way up there in the woods just at the edge of the forest. I think it was called Glenwood. The postmaster came out and asked if I was Walter Lawton, and I told him I was, and he had a whole package of letters that had come there that had piled up. They'd gotten in the wrong place. That's why I hadn't heard from them all that time. Some way or another, they got them sent to that little post office and he didn't know where I was, and he figured I was a sheep herder and that I'd come out sometime, and so he kept them there for me.

It is not hard to imagine Walt binge-reading his letters as he walked along and again when he stopped that night. His relief must have been palpable as he caught up on the news from home, and relaxed knowing they had been writing all along.

So they headed down out of the mountains toward the plains of the Columbia Plateau. It was snowing the day they left. The diminished outfit returned more or less the way it came, past the site of the shale slide, over the deadly rail crossing, and past Winona, although this time there was no girl threatening with a rifle. It was just as well. Bob was no longer there to upset her and Walt, with his peculiar brand of diplomacy and chivalry. Pete was supposed to scout around for stubble for the sheep to graze on, but his heart wasn't in it and he didn't seem to try all that hard.

> He was reluctant to leave the trail and you couldn't find much stubble unless you did. So finally he called up the boss and said we couldn't find any stubble, so he said "bring 'em on home," and we got in just about the middle of October….

The final event of the annual cycle of sheep ranching, was shipping and selling the lambs that were born in the spring and fed all summer. But even before that was done, the next year's cycle got underway when the rams were turned loose among the ewes for breeding. This was timed to stretch the lambing season out to make it manageable. Walt noted:

> Say you were running three bands of sheep, four bands of sheep, you would space 'em out so your lambs would be coming, you'd try to get 'em all lambed out in about 30 days. Say you had 4,000 sheep, you would have 2,000 of them breeding (at the same time) so they'd come along, then about two weeks later the others, so you never had the whole works in (the lambing sheds) at the same time.

After the breeding season was over and the winter had passed, the first work of the spring was shearing. As we have seen, Walt wanted to learn shearing, but since Roy (Walt's mentor) wasn't shearing that year, herding was his destiny. The advantage of sheep over cattle was that they produced two crops each year—lambs in the fall and wool in the spring. When wool prices were high, they could keep some wethers over for a number of years for shearing, rather than selling all of them into the lamb market.

Soon after the shearing was done, the lambing season began.

> Years ago they used to lamb on the (open) range, some of them would have pens on the range where they'd herd around there, and they'd drop some lambs, get the ewes and lambs into a pen until another man came out to work them in together.

By the time Walt got into the business, lambing on the open range was a thing of the past. It had moved to the ranches and inside, into sheds, such as they were.

When the ewes were ready to drop their lambs, a "pick and drop" man would take the lamb to a small pen about three feet square, and put the ewe in with it. As Walt explained, the "catch pen man" would put the lamb in place and get it to begin to suckle:

> … get some milk in him; they're kind of stupid, just as apt to start butting at one end (of the ewe) as the other. Take them a while unless they're pretty strong, they couldn't find the food until it was too late, so you always tried to get 'em one belly full of milk.

The lambing operation also required a "feeder," that fed the sheep and cleaned the pens.

Ewes and their lambs have to be paired and kept together until the ewe can recognize her lamb by smell, then they have to be gradually worked into larger groupings until they finally are assembled into a band. Walt explained:

> then they'd keep 'em in there (the first pen) about 24 hours, then put 'em out, the twins you'd put 'em in one band, put the singles in another band, keep 'em separate, keep them moving out—at

first you'd put about 20 ewes and their lambs in a pen another day, and then move them on, double 'em up till finally about four or five days old they'd go in a bigger band which was made up to go out in the mountains.

There were always orphans and bum lambs whose mothers had died, or were a twin that had been rejected. These were either hand-fed or paired with a mother whose lamb had died. In the latter case, they often would skin the dead lamb and pull the pelt over a lamb needing a mother to fool her by smell, into accepting it as her own.

Finally, the bands were assembled and the trek to the mountains began once more. Walt didn't go this time; he went back to school. But a year later, he left school again, and went back to the ranches and the mountains for two more years, this time herding for Roy Parsell.

This way of life and the sheep industry gradually faded over the next half century or so. Today, we get most of our lamb from Australia and New Zealand, although there are still a few sheep ranches in Montana and other parts of the mountain west. There are even some drives to grazing allotments in the mountains, but they are few and far between. They are relatively short treks to nearby grazing areas, rather than the long drives across plains and prairies. Most herders today are Mexican, and llamas are put into the herds to ward off coyotes. While Australian Shepherds and Border Collies are still the herding dogs of choice, breeds of guard dogs that will tackle a bear, such as the Karelian bear dog, have been introduced as well.

There are many places around the world where rural economies are based largely on raising sheep. In mountainous regions of Central Asia, the ancient cycle of wintering in the lowlands and summering in the mountains still is practiced much as it was in this country a century ago. In the herding cultures of Central Asia, men still pride themselves on being able to kill, dress, and place a lamb on a cooking fire in 45 minutes. And Pete's method of dealing with the sheep head and the tasty delicacies contained within is pretty much the same there, except that it is done with great ceremony at the beginning of traditional dinners. The eye is prized, not because it is particularly tasty, but because it symbolizes the hope that guests and hosts will see each other again.

Like all of our historical and cultural artifacts, something is diminished when they fade away. But they often live on in stories and in faraway places, so they are not completely lost.

Walter Lawton went back to school in Grandview after three years working on ranches and in the mountain sheep camps. His sister Erma and her husband, and their little girl, Gwen, had moved to Grandview in 1920. Helen and their mother, Irene, had recently settled there after following Helen's teaching jobs in Montana. Lester eventually showed up to finish high school after his years working at Spokane's Davenport hotel as a busboy. But it took Walt a while to shake off the habits of the sheep camps. For many years his sisters enjoyed telling the story of his first Sunday dinner at home, when after wolfing down a piece of fried chicken, he tossed the bone over his shoulder onto the floor. Sheepishly, he picked it up as his family laughed.

By the time Walt came to Grandview he was 18. He was bigger and stronger than anyone else, so he was pressed into service as a lineman on the football team. Eligibility rules were different then, if they had any such rules. Although he often said he did not much like the game, he was a popular and respected player. He graduated in 1928 when he was 20.

Left: Walter Lawton when he returned to high school in his late teens following three years in the sheep camps. Nicknamed "Hefty" he was a standout lineman for the Grandview, Washington, High School football team.

Below: Photograph of the entire team. Walt is second from the right, front row.

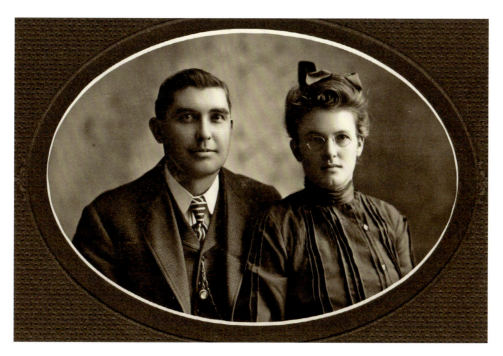

Photograph of Oscar, Will's younger brother, with his wife, Lenore. "Uncle Oscar and Aunt Lenore" lived in nearby Cheney and some or all of Will and Irene's children lived with them from time to time to attend high school since there was none at Fishtrap. Walter lived with them for a short time to attend the Cheney Normal School but it did not work out and he moved on. Oscar died of a stroke at age 59 in 1929. He lived the longest of this short-lived family.

Will's brother Oscar died of a stroke in 1929. He was aged 59. He lived the longest of his generation.

Walt went on to marry and have a family, but following the family tradition, he never really stopped wandering, always looking for greener pastures. He knew that he would die of a stroke by the time he reached his early fifties. After all, his father and his father's sisters and brother, and his grandfather had all died in just this manner before him. Walt lived his life anticipating early death. He turned to religious faith when he was about 40. From then on, he seemed to live for the next world, eschewing this one by accepting the smothering embrace of poverty, by dedicating himself to Christian service, and by adopting a Christian strain of thought that this world and its evils are largely to be avoided.

But he surprised himself and did not die. Later in life he told one of his sons that he might have done some things differently had he known he would live so long. He lived to be 86, more like his mother, Irene, who died in Spokane in 1950 at the age of 84. But we do not know what he would have done differently, because he never said. His approach to life held some inconveniences for his family, but, of course, every generation is saddled with consequences from the choices its parents make, since it can hardly be otherwise. In this case, the two generations of premature death that cast a pall over the family's life and livelihood, seemed to come to an end, or at least to moderate.

Three major events affected my father's early life and subsequent development into manhood. The loss of his dad at age seven was the most pronounced. Will and Walt were dissimilar people. Will was an outgoing, high energy, expressive and venturesome man. He was the leader of a large extended family. Walt was a quiet, self-contained, "strong silent type" man, authoritarian when he was younger to the point of being scary, especially to some of my cousins on my mother's side. He was the leader of a small, somewhat isolated, blended family. Will was all about extended family; Walt kept his distance. He seemed more like his taciturn grandfather, Jay Bump, than like his father, although he eventually mellowed from his hard line self into being more of a gentle teddy bear sort of person. There are a lot of reasons why people develop the personalities they do but often some of the reasons stand out and you don't have to be a psychologist to see what they are. As the youngest child of Will and Irene, Walt lost the father he adored, the dad who doted on him, at a tender age. His mother never remarried and there was no real substitute father available. I believe this profound loss tended to turn his naturally introverted personality further inward.

A few years after they lost their father, the family lost their home and businesses. The scablands community of Fishtrap is where Walt was born; he had never known anything else. He loved his home and the land, rocky as it may have been. And to be more or less on his own before he was fourteen, would have added further to his sense of isolation and perhaps abandonment.

And then there were the sheep herding years, also taking place during a formative period of his life. To be turned out in the wilderness after severe losses in his life, often in complete solitude save for the animals, for three years out of four, seems almost inhuman today. It is small wonder that he seemed silent and often distant. The God he worshipped was strict, harsh, vengeful, and demanding perfection, seeming to come more from the Old Testament, though He was claimed to be from the New. His was a God with a decidedly mixed and conflicting set of messages, many of them punitive. Looking at Walt's early life with its deep and abiding losses, it is not too hard to figure this out either. Will's life was no picnic, but his tragic losses did not begin until he was about sixteen, well after the most formative period of his childhood. He was capable of stepping in as the leader of the family after his father's fatal stroke; Walt, at seven years old, was not.

My journey of discovering and writing down these stories has been a long one, covering some two decades. I have written, rewritten, and re-rewritten. It was a quest born of curiosity stemming from the discovery of some artifacts from a hundred years ago. It ended with understanding … and forgiveness.

Bibliographic Essay

Jay W. Bump, Irene's father and my great-grandfather, kept a diary for most of his adult life. These diaries provide basic information for the Mondovi and Eau Claire period and for the Spokane years included in Part One. The diaries are part of my personal collection. They are written in a cryptic manner and are difficult to decipher and read. But, with a little work, they are an invaluable source for understanding daily life in Mondovi and then Spokane through 1896, the year that Jay Bump died. They also serve as a pointer in that one can find the dates of significant events then go to other sources for more detail.

For the overall history of the Lawton family, I relied on Dick Lawton (Will's brother Oscar's son), *My Lawton Ancestors in the United States*, an unpublished genealogy in my personal collection. For information on all the families in this work, I consulted an untitled and unpublished genealogy by Walter's sister, Helen J. Lawton, also in my personal collection. The Bump family Bible, also in my library, helped with certain names and dates. For example, my grandmother's name is listed as Irene Elizabeth or other variations depending on the source. I used "Lizzie Irene," which is written in the family Bible in her mother's (Charlotte Bump's) hand. I also used ancestry.com to track down census data, birth and death records, and military information. I was able to confirm information that I already knew from family stories. I knew, for example, that Will's mother, Maria, took in washing for a living after her husband, Lewis, died. My mother told me this and I was able to confirm it through Wisconsin census data where she was listed as "wash woman" in 1885.

For the Mondovi connection, the following works were used: Donald E. Walter, ed., *Lincoln County; A Lasting Legacy* (Davenport, Washington, Lincoln County Centennial Committee, 1988); Carolee Rzepiejowski, "Brave Beginnings," *Wisconsin West Magazine* vol. 6 No. 2, March, 1993; Houser Rockwell, *West Central Wisconsin and Mondovi Area History*, (Mondovi Area Historical Society, 1988); and reprinted in Rockwell, George B. Baker, an untitled article on the Mondovi wagon train based on the diaries of Lucy S. Ide, appearing in the *Chronicle Dispatch*, Dayton, Washington, September 14, 1933. These references tell part of the story of the move from Mondovi, Wisconsin, to Mondovi, Washington. The connection from Mondovi to the Spokane railroad migration was made based on the diaries of Jay W. Bump, newspaper articles, maps, and the obituaries of Mensus R. and Gile O. Bump. The story of the fire at the Bump Block was based on the Jay Bump diaries and Scott Brooks-Miller and Nancy Compau, "Spokane Register of Historic Places: Nomination Form, Bump Block/Carlyle Hotel" (City of

Spokane, 1989). A somewhat different version of the story is contained in an amended version of the Nomination Form dated June, 2000. This is the source of disagreement over where the carriage repository was located. Based on Jay Bump's diaries, I tend to favor the first version of the first floor of the hotel building, but cannot prove it.

Newspaper articles included an account of Leslie O. Frizzell's death, in "Fatal Wreck: A Northern Pacific Freight Plunges into the River," *The Spokane Weekly Chronicle*, August 27, 1896; and "School Teacher Passes Away," *Spokesman Review*, November 13, 1904. The latter article covered Will Lawton's sister Sarah Lawton's untimely "stroke of paralysis" as she taught in her classroom. The Polk City Directories for Spokane were helpful in tracking the residences and businesses of various people covered in the book. Finally, I have a sizeable photo collection, much of which is included in this work and was helpful in piecing the story together. Sometimes a picture really is worth a thousand words.

Much of the material for Part One first appeared in John W. Lawton, "Painting Spokane," *Nostalgia Magazine*, Spokane, August 2000. The article was updated for this work. It was first copyrighted in 1996 in an unpublished collection by John W. Lawton called *Love from Papa*.

Part Two begins with the history of the channeled scablands. Many articles have been written and are still being written about the geologic history of this area of eastern Washington and the skepticism that J. Harlan Bretz had to overcome in establishing the theory of the floods. A few of these articles, including the ones I read for this work, are Michael Parfit, "The Floods that Carved the West," *Smithsonian Magazine*, April, 1995; Paul L. Weis, "Geologic History of Lincoln and Adams Counties, Washington," in Southeastern Lincoln County Historical Society, *Sprague, Lamont, Edwall, Washington, 1881–1981* (Fairfield, Washington, Ye Galleon Press, 1982); Paul L. Weis and W. L. Newman, *The Channeled Scablands of Eastern Washington: The Geologic History of the Spokane Flood* (Cheney, Eastern Washington University Press, 1989); and finally, U.S. Department of the Interior, Geologic Survey, *The Channeled Scablands of Eastern Washington: The Geologic Story of the Spokane Flood*, 1973.

Very little has been written about Fishtrap, and its surrounding community, at least in published form. It merits a paragraph in a couple of books of place names, including Edmond S. Meany, *Origin of Washington Geographic Names*, (Seattle, University of Washington Press, 1923, republished by Gale Research Co., Book Tower, Detroit, 1968); and Robert Hitchman, *Place Names of Washington* (Olympia, Washington State Historical Society, 1985).

The only other work I found with specific references to the community of Fishtrap is also a good source of material on the general history of the area. This is Southeastern Lincoln County Historical Society, *Sprague, Lamont, Edwall, Washington: Stories of Our People, Land and Times, 1881–1981* (Fairfield, Washington, Ye Galleon Press, 1982). It is a large compilation of newspaper articles, family histories, and articles written for the book, like many others of its genre. In addition to the Weis piece noted above, I found an article by Frank Slagle, "The Great Inroads," on the Mullan and Colville Roads; and one by Nina Henton Lung, "Henton Family History (1908–1920)" to be especially useful. The book also contains a great deal of information on early Sprague history. The only other published source I found specifically on Fishtrap, was Guy Reed Ramsey, *Postmarked Washington* privately published by Vern M. Anderson and Donna Armstrong, 1977). This provides a history of the post office at Fishtrap, which I relied on in addition to postal documents from the National Archives referenced below.

For an understanding of the history of the broader area of the scablands and southeastern Washington, especially as it relates to the homesteading period, I used several works. Alexander Campbell McGregor, *Counting Sheep: From Open Range to Agribusiness on the Columbia Plateau* (Seattle, University of Washington Press, 1982, paperback, 1989) includes a comprehensive and definitive history of the sheep business in the area. It also has a couple of pages on the problem of cheatgrass. A treatment of the homesteading laws is contained in Walter M. Yeager, "The Pioneer's Problems of Land Acquisition Under the Public Land Laws in Southeastern Washington: 1850–1883" (Masters' Thesis, Washington State University, 1961).

Continuing with the broad history of the area, the U.S. Bureau of Land Management has purchased some 8,000 acres of the scablands for wetlands restoration. They are also preserving a couple of farmsteads as part of the local history. In Will Lawton's day, these were the McCroskey and Folsom places, which were both within the Fishtrap community. I walked the homesteads with Rich Bailey, a BLM archaeologist, who helped me understand the area better and who also provided me with two documents and pointed me to a third which I used in this work. They were U.S. Department of the Interior, Bureau of Land Management, "Request for Determination of Eligibility: Smick Farmstead," by Jerry White with assistance from Judy A. Thompson, Spokane, Washington, 1994; U.S. Department of the Interior, Bureau of Land Management, "Request for Determination of Eligibility: McCroskey or Miller Ranch," by Judy A. Thompson with assistance from Jerry White and Rich Bailey, Spokane, Washington, 1993; and Glen Lindeman and Keith Williams, "Agriculture Study Unit," Revised by Office of Archaeology and Historic Preservation, Olympia, Washington, 1986. The first two works provide history of the area, and the latter provides an economic framework for viewing the homestead cycle.

For the history of railroading in the northwest, I read Michael P. Malone, *James J. Hill: Empire Builder of the Northwest* (Norman, University of Oklahoma Press, 1996), which, by the way, also provided the model for this bibliographic essay; and Bill Yenne, *The Great Railroads of the Northwest* (Ottenheimer Publishers, 1995).

For more specific information about Fishtrap, I used a combination of interviews, archival material, and documents in my personal collection. These included the letters to my grandmother, Irene, from my grandfather, Will Lawton, which are cited herein. One name in the letters was changed because of the nature of comments about the particular individual. The information also included articles from the Sprague newspapers of the day. I am deeply indebted to Albert Russell Svahn, whose father bought the store and farm from my grandmother. Mr. Svahn made a special trip in the late 1990s to Spokane from San Diego to tour the place with me. We located foundations and the places of everything from root cellars to outhouses. I had many phone conversations with him about life at the store and at Fishtrap.

Archival material includes U.S. Department of the Interior, U.S. Land Office, *Tract Book* vol. 82, Washington, National Archives; and U.S. Department of the Interior, "Homestead Entry Final Proof," J. W. Lawton, Serial No. 02825, Homestead Entry No. 17292, Patent No. 275237, National Archives. The latter constitutes the "Homestead File" and has a great deal of information about the property, its settlement, and even some personal information. Included are the depositions of Will and two of his neighbors regarding the history of the property.

Other archival documents include Washington State Archives, Eastern Regional Branch, Eastern Washington University, "District Clerk's Annual Reports" and related documents,

Lincoln County School District 104, 1898–1929; Post Office Department, "Record of Appointments of Post Masters 1832 to September 30, 1971," Microfilm Publication M 841, 0183–09, Roll 137, National Archives, and Post Office Department, "Reports of Site Locations 1937–1950," Microfilm Publication M1126, 149–01, Roll 632, National Archives.

Much of the daily life at Fishtrap was gleaned from the Sprague weekly newspaper, which went by various names, *The Sprague Times*, *The Independent Times*, and *The Sprague Advocate*. This paper is available on microfilm at the Sprague Library and the Eastern Washington University Library. The comings and goings at Fishtrap were chronicled sporadically in a column called "Lake Valley News." I also relied on my own personal collection of deeds and other legal documents concerning the properties at Fishtrap. The collection is complete, saving several trips to the county courthouse. My collection of photographs also helped me understand life at Fishtrap. My cousin, Gwen (Dyer) Hodkinson, who was born there is still a source of information; and my mother, Mona Lawton, helped me fill in the details before she passed away in the year 2000. She helped me confirm many items which she recalled from conversations with her mother in law, Irene. Finally, Mike Barker, present owner and operator of the Fishtrap Lake Resort, has been helpful with the history of the resort and in allowing me to wander around and take photographs there.

Part Three is based almost entirely on Walter W. Lawton's Personal Recollections of his three years in the sheep camps. In 1985 I sat down with my father, and I recorded his memories of those times. I did not do anything with the tapes for over 20 years. My interest revived when I saw a 2009 film documentary called "Sweetgrass," directed by Lucien Castaing-Taylor and produced by Ilisa Barbash. It documents one of the last sheep drives into the Absoroka-Beartooth Mountains of Montana in 2003. It has neither narration nor music, and it beautifully records what a drive to summer grazing was like. This stimulated me to get out the tapes, transcribe them, and organize the material into this narrative. In addition to my father's specific recollections and the overall ambience provided by the film "Sweetgrass," the main source I consulted was Stephen J. Pyne, *Year of the Fires: The Story of the Great Fires of 1910* (Missoula, Mountain Press Publishing Co., 2008). The brief discussion of the 1910 fires was based on this detailed and thorough work.